PREHIST⊕RIC
WILTSHIRE
An Illustrated Guide

BOB CLARKE
FOREWORD BY FRANCIS PRYOR

AMBERLEY

First published 2011

Amberley Publishing
The Hill, Stroud,
Gloucestershire, GL5 4EP

www.amberley-books.com

ISBN 978-1-84868-877-3

British Library Cataloguing in Publication Data.
A catalogue record for this book is available from the British Library.

Typeset in 10pt on 13pt Celeste.
Typesetting by Amberley Publishing.
Printed in the UK.

Contents

Foreword

This is a remarkable book. A good read with great pictures. It's also far more than an account of the principal prehistoric sites of Wiltshire, because it includes a lot of new material. Of course the main facts have come from archaeological publications and reports of old excavations – such information is indispensable – but each site has been visited by the author. There are wonderful photographs of fabulous things being unearthed. These informal pictures make the book come alive: it's as if we were looking at video footage, only the still pictures – like those on the radio – are far, far better than wobbly news clips. They allow our imaginations to get to work. Looking at the photos, I could almost smell the atmosphere of the dig in 2002, when the well-known archer burials were revealed by Wessex Archaeology.

The book also includes some surprises, even for a professional prehistorian. I had heard of the famous axe-polishing stone, or polissoir, on Overton Down, but I'd never found it myself. But Bob Clarke had – and he'd taken some wonderful pictures. Incidentally, I discovered a small polissoir of my own, which we excavated from a pit in the Neolithic site at Etton, just north of Peterborough. But our one was only used to polish the blade and flat surfaces of stone axes, whereas the one on Overton Down had a variety of grinding surfaces, sufficient to make a complete axe from a rough-out. Sarsen stone is incredibly hard, so the making of that polissoir itself must have been a major effort. And yet it doesn't appear to have been sited inside a large settlement. What does that tell us about the people who created those beautiful axes that today adorn the shelves of Wiltshire Heritage Museum? In prehistory nothing is ever as simple as it seems.

Some books relegate the people who helped the author to a few names listed in the acknowledgements, but Bob Clarke publishes their pictures, too. This also helps bring the book to life: not only do we see the colleagues who took, or helped Bob take the stunning aerial photos, but we also get to see the plane!

I think the biggest tribute I can pay to this book is that the more I read, the more I wanted to lay it aside, put on my boots and tramp the fields and plains of Wiltshire. That's what I call inspiration.

Francis Pryor
July 2011

Acknowledgements

In 2009, the Wiltshire Archaeological and Natural History Society launched an appeal to update the current Bronze Age gallery at the Museum in Devizes. The plan is ambitious; it is also needed. The collection is recognised as one of National Importance and, as such, needs to be presented in an accessible and up-to-date manner. As you would expect, this requires substantial investment, some of which has been secured from national organisations, but the appeal continues. This book is my contribution to that effort.

A project like this relies on the good nature of many individuals and organisations. They are: David Dawson, Bill Perry, Ellie Pridgeon, Sarah Harris and the rest of the staff and volunteers at the society's museum at Devizes; those who supported the aerial work, including GS Aviation at Clench Common, Marlborough, The Bustard Club, Boscombe Down and pilots Mark Hayter, Richard Johnson and Mike Fuller but especially Martin Kellett for the opportunity to fly in a Schneider Trophy winner! Many archaeologists have given images or advice to the project, and these include Mike Pitts, Jim Leary, Alasdair Whittle, Josh Pollard, Mike Parker Pearson, Julian Richards, Jim Gunter, Ros Cleal, Debie Edmonds, Andrew Fitzpatrick, Margaret Bunyard and all those at Wessex Archaeology with whom I worked during the 'Boscombe Down days' and who have agreed to the use of the photographs! A special thank you to professional landscape photographer Bill Bevan who has also donated to the cause. More of Bill's work can be found at www.billbevanphotography.co.uk

My proofing team Teresa and Al Thomas, Steve Warner, David Dawson and Sarah Clarke made some excellent suggestions. Thanks are also due to Katy Whitaker who produced a splendid piece on Experimental Archaeology at such short notice and last, but definitely not least, Francis Pryor. The support of such an eminent archaeological figure adds weight to our cause – thank you Francis.

As always, my family have featured heavily in the preparatory work, accompanying me in the aircraft or just jumping in the car for a ride out. Even the challenging quest for the Polissoir on Overton Down (we had two attempts) turned into an adventure – I've promised them we will be researching a book on Bali next!

Introduction

In my formative archaeological years, two books were my bible: *Collins Field Guide Archaeology in Britain* by Eric Wood (1973) and *The Penguin Guide to Prehistoric England and Wales* by James Dyer (1981). Talking to colleagues, it appears I was not the only one who navigated the country with a copy of Wood close to hand. When, in October 2009, Bill Perry sent out a call to raise funds for the restructuring of the Prehistoric Gallery at the Wiltshire Archaeological and Natural History Society's (WANHS) museum in Devizes, I had an idea. Rather than donate money, it seemed something longer-lasting might be in order. After fifteen years working in and around the county, much of it from the air, it struck me that a guide with some basic, up-to-date information was needed. With an air of self-indulgence, I decided it was time for a guide to the prehistoric sites – as I saw them – of Wiltshire. Suffice to say, this is my own personal selection; one that I hope will give you a balanced view of what this fantastic county has to offer.

Wiltshire is a county full of prehistoric superlatives; the UNESCO World Heritage site, encompassing both the Avebury and Stonehenge landscapes, stands testament to that. Wiltshire comprises far more than just the two world-famous complexes however. Peter Reynolds once told me, 'Climate drives landscape, drives man'. This is especially true of Wiltshire, and goes some way to explaining the plethora of early monuments recognised across the chalk downs. The county is home to an impressive array of archaeological sites, including intensive areas of settlement, hillforts, long and round barrows, and of course enigmas, such as Silbury Hill. Indeed, the County record spans many thousands of entries – there are over 350 Scheduled Ancient Monuments on Salisbury Plain alone.

From the outset, the question has been 'who would benefit most from the sites included in this guide?' It has always been my intention to make archaeology as accessible as possible, and the structure of this guide was designed with that in mind. Rather than write a technical, fully referenced work, it appeared more advantageous to produce a handy representation of the known facts and leave it at that. So what does the casual visitor require to experience one or other of the county's prehistoric sites? Each site comprises a number of themes, including location, previous investigations and photographs to complement the visitors' experience. Whilst the work is not referenced, further reading is suggested. That said, it is worth noting that, where possible, the information imparted was drawn from the pages

The Wiltshire Heritage Museum, 41 Long Street, Devizes, Wiltshire, SN10 1NS, Tel. 01380 722150
www.wiltshireheritage.org.uk

of the *Wiltshire Archaeological and Natural History Magazine*. Artefacts from the majority of sites mentioned here are in the WANHS collection housed at Devizes. Furthermore, I decided early on in the production that a plan of each site was a poor use of space; a recent aerial photograph takes its place where possible.

The most difficult part of this work has been how to set out the county landscape. Originally, the idea was to give a brief introduction to each period and then lay out the monuments from that era. Unfortunately, many of Wiltshire's prehistoric monuments adhere to the old rule 'once a good site, always a good site', and are subsequently multi-period. Instead, I've introduced a geographical framework, hopefully ensuring you have the opportunity to visit a multitude of sites in one or other areas of the county. Each proposed landscape group runs, where possible, from the earliest to the latest site. Any multi-phase monument takes the earliest as its place in the framework.

As to visiting the monuments and landscapes described here, all you need to use this guide effectively is a current 1:25,000 Ordnance Survey map. The information at the end of each monument will provide a National Grid Reference, to at least six figures in the case of large sites, down to the occasional ten figure set for specific features. I also provide a suggested parking spot, time and distance to site and, most importantly, a note on terrain.

Only time will tell whether the format works. I have visited every site included here over the last eighteen months, some admittedly by air, but mostly accompanied by my family – something I hope you will all do – often experiencing sites with new eyes. Of all the fabulous sites we visited, probably the most cathartic for me was the tranquillity discovered at The Devil's Den early one Sunday morning in September. And then there's the invigorating experience of Adam's Grave on a windy day – I could go on. Visit the sites mentioned here, visit the Wiltshire Heritage Museum in Devizes, but most of all, enjoy the Wiltshire landscape and its many spectacular prehistoric sites.

Bob Clarke
March 2011

Notes on Using the Guide

First and foremost, please ensure you are properly equipped for a visit to the sites noted here. A decent pair of walking boots is a must, as many prehistoric sites include banks and ditches – indeed they are invariably uneven. Rabbits and badgers further exacerbate the problem. For the longer walks, please go prepared for a change of weather – this is the United Kingdom after all! To ensure success on each tour, you should equip yourself with the appropriate Ordnance Survey map. The OS Explorer series, with a scale of 1:25,000 – that is 4cm to 1km – is sufficient to provide a fairly accurate representation of the current rights of way. That said, this guide does not infer public rights of way as these can change, and if in doubt please check with Wiltshire County Council prior to setting out, at rightsofway@wiltshire.gov.uk.

Using the National Grid Reference (NGR) for a given site is straightforward. Each NGR starts with two letters, which refer to the 100km square imposed nationally by the Ordnance Survey. The following two sets of numbers refer to eastings and northings, allowing you to navigate to a given map reference. A 1:25,000 map is divided into 1km squares and each is further divided into 100m on the edges of the sheet.

Example:
Barbury Castle is located at NGR SU 149 763.

Take the appropriate map and follow the numbers in blue along the bottom edge of the map until you reach 14, then, using the segments between 14 and 15, count 9. This gives you the easting of the site. Follow the blue numbers up the side of the sheet until you reach 76, then count the segments for a further 3 – this is the northing. The location of the site is where both lines cross.

A Note on Periods

Archaeologists are renowned for their ability to throw out a bewildering array of period names and dates, often confusing the uninitiated. Having read back through the draft of this work, it would appear I am no exception! What follows is a brief précis of the periods as we recognise them today. Naturally, these periods are in a constant state of flux, as new work and more effective scientific techniques provide an ever more-detailed picture of the prehistory of Britain. It is important to note that no period as described here is intended to infer a watershed. The adoption of one technology over another, or the transmission of new ideas, takes hundreds of years; indeed, we are still living with this process. How many town councils today have their offices in Victorian buildings? And what about churches? Avebury church has evidence of a pre-conquest (1066), Anglo-Saxon building at its core. That is a thousand years of a similar activity on one site – you get the idea.

Mesolithic (Middle Stone Age)

The last 500,000 years of European Prehistory have been punctuated by episodes of severe glaciation. Between such climatic events, humans appear to have been in the British landscape. Unfortunately, the only evidence for this are the occasional finds of stone tools. This period is known as the Palaeolithic (Old Stone Age). That said, there has recently been a concentration of finds near what is now Salisbury. It is after the final glaciation that everything changes.

As the ice retreated, c. 11,500 BP (Before Present), for the final time the deciduous forest moved steadily northward, bringing with it animals and people. Not a general influx, more likely small hunting groups who followed the herds as they migrated between high and low ground. These groups are known as Mesolithic hunter-gatherers. The fact they were mobile makes identifying them in the landscape difficult. One key point here is that the British Isles as we recognise them only came about after c. 7000 BC. The combination of the ice melt-water raising sea levels and the isostatic rebound (the UK was depressed into the mantle by the huge weight of the ice) led to the formation of the English Channel and North Sea. This does not infer a population cut off from Europe, but it does drive artefactual idiosyncrasies

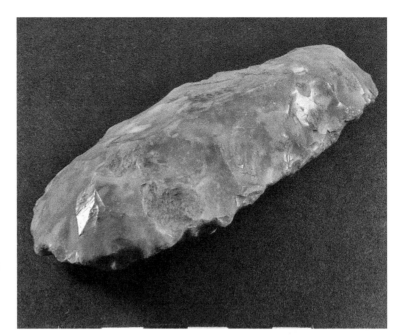

A Mesolithic flint tranchet axe, discovered at Aldbourne. Mesolithic stone tools are small when compared with earlier and later artefacts, taken to signify a high degree of mobility. (Wiltshire Heritage Museum)

in the archaeological record. Within Wiltshire, as with other counties, evidence is almost exclusively restricted to flint tool finds. Phil Harding has recently published work on the distribution of this material across the north of the county, but points out the Wiltshire Sites & Monuments Record holds an incredible 529 find-spots.

The reason for flint being our almost sole indicator is driven by the Mesolithic groups' transitory lifestyle. Tools tend to be small and portable, contrasting with later periods. As people probably stayed in temporary camps, they left few traces, and would have moved with the seasons. A family or kinship group may have ranged over a hunting area covering hundreds of hectares, encompassing many natural resources. Key to this is the use of rivers valleys and lagoons, presumably good sources of food through fish and fowl. That said, the chalk massif of Salisbury Plain and the Marlborough Downs would also have been a draw in this period. So do they fit into the story of the Wiltshire landscape, or were they just passing through?

A number of temporary camp sites have been recognised in the county. At Cherhill, near Calne, an area of limited occupation was excavated in 1967 by John Evans and Isobel Smith. The site was identified by large amounts of flint working debris, evidence of fires and animal bone. A singular radiocarbon date suggested a mid-sixth millennium BC date for the site. The previous year, three substantial post holes had been located a few hundred metres north-west of Stonehenge; these returned a radiocarbon determination of 7180 +-180 BC. They may be part of a line of posts. perhaps 6–8 metres high, across the sire that was to become Stonehenge. Then, in 1997, Ian Dennis, working with postgraduate students from Cardiff, located the floors of three dwellings on Golden Ball Hill, 1 kilometre east of the Knap Hill causewayed enclosure. It is thought these structures appeared around 4500 BC, but by then a new technology was already moving into Britain – Agriculture.

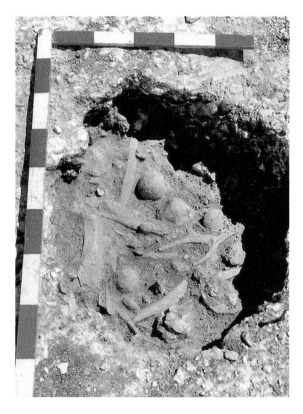

Neolithic pit excavated at Boscombe Down in 1996. The contents of this included antler, animal bone, hammer stones and worked flint. The antler and hammer stones can be clearly seen. (Boscombe Down Conservation Group)

Neolithic (New Stone Age)

The introduction of agricultural practices into the United Kingdom changed the landscape forever. However, this change was not an overnight phenomenon, rather a gradual transition over 1,000 years. The evidence left by the 'pioneer' farmers can be readily distinguished from the cultural assemblage of the Mesolithic. The Neolithic artefacts clearly indicate a more sedentary way of life. Sites we recognise as early Neolithic still show that people moved frequently, but early examples of pottery and larger flint tools and axes indicate that people were travelling shorter distances. The beginning of the domestication of animals and husbandry are also markers in the archaeological record at the time. One other activity sets them apart from the Mesolithic population – the growing of grain.

Currently, it is difficult to ascertain the use grain was put to by the early farming population. What is clear is that around 5000 - 4500 BC domesticated cereals were imported to Britain, as no such species grew wild here. Growing crops introduced a radically different way of life, and to suggest indigenous groups simply 'switched over' would be wrong. It is highly probable that the two lifestyle types (hunter-gatherer and agriculturalist) existed together for a long period. Subsequently, the boundaries between both practices were fairly well diffused, groups reverting to gathering and wild animals in times of crisis.

To clear and prepare land is a time-consuming, labour-intensive process. As the crop germinates, animals have to be kept off and weeds kept down. Once ripened it needs to be harvested, processed and stored. Naturally, all this curtails any great movement away

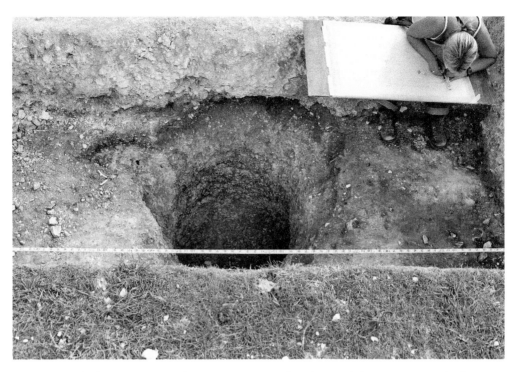

A huge post hole being recorded at Durrington Walls. The Neolithic was a period of intense construction work on a monumental scale. (Bob Clarke)

from the growing area; this is the key to the monumental landscape. As groups became more sedentary, they increasingly began to manipulate their surrounding landscape. This manifests itself in a number of ways. Probably most important was the success of the group itself. The production of children increases the group size and subsequently the area in which the group can farm; a bigger group size requires a larger area, which in turn produces more population. Visible aspects also become apparent, land clearance leads to a change in vegetation cover, the erection of more permanent dwellings and markers to demonstrate ownership. That ownership is coupled with a sense of place and belonging; pits with special deposits begin to appear followed by larger sites, such as the long barrows and later causewayed enclosures. This monumentalisation reaches its zenith with the complexes at Avebury. So agriculture becomes two things, a way of life that cannot be abandoned and the catalyst for the monumental landscape – many examples of which appear in this guide.

Beaker (Chalcolithic)

One of the most significant events in the prehistory of the British Isles happened around the middle of the third millennium BC with the arrival of metal objects. The importance of this cannot be overstated. Initially, small knives of copper and then high copper content bronze were introduced. These were occasionally complemented by small items of gold – the earliest currently discovered in the United Kingdom being the hair tress discovered

13

by Andrew Fitzpatrick, with the Amesbury Archer and his companion, dating from 2470 BC. These early artefacts probably had a more symbolic than practical use. However, from these humble beginnings came harder, bronze tools, and these were to shape the British landscape. Probably the greatest and most visible aspect is the resultant forest clearance. Axe technology developed throughout the early Bronze Age, with better, more effective designs in evidence across the country. This was closely followed by longer knives, spears and eventually swords. These changes took a millenia.

The Amesbury Archer should not be seen as one indicator of a full-scale migration. More likely, a small number of individuals initially set out to 'open up new lands'. The Archer, as indicated by the analysis of isotopes in his teeth, came from the Austrian/Swiss area of Europe – quite an incredible distance 4,500 years ago. The enamel of an adult tooth can provide geographical information. As the second set forms in the jaw, it locks in the strontium signature of the local water. Geologically, the levels are different; a match shows where the individual spent their childhood. His burial, and many others recognised across Europe, are known as 'Beakers', named after the fine, distinctively-shaped pottery type they were often buried with.

The Beakers are the catalyst for another major change in the indigenous population – the treatment of the dead. This period marks a move away from collective monumental

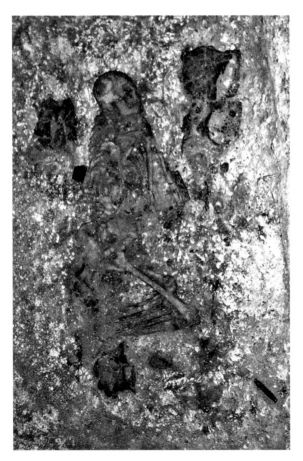

Left: The Amesbury Archer, the richest Beaker grave yet discovered in the United Kingdom. The photograph appears the way it does as the excavation went on through the night. (© Wessex Archaeology)

Opposite above: A series of complete barbed and tanged arrowheads from the Amesbury Archer's grave. (Elaine A. Wakefield © Wessex Archaeology)

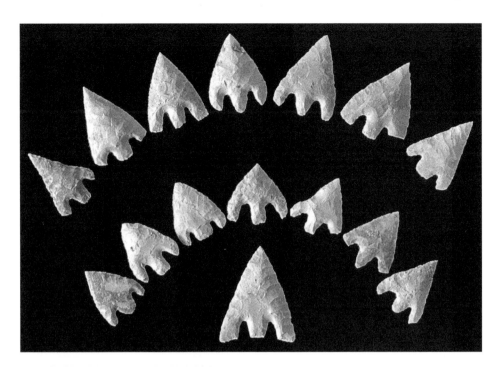

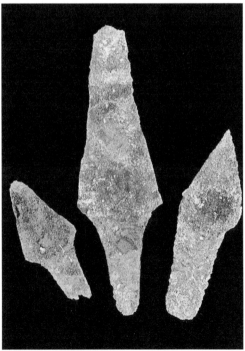

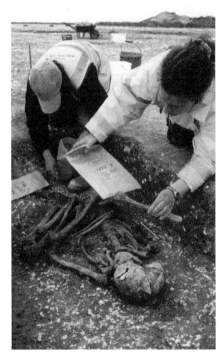

Left: Some of the earliest metalwork yet discovered in the United Kingdom. (Elaine A. Wakefield © Wessex Archaeology)

Right: The Archer's companion, during excavation by the Wessex Archaeology team. (Elaine A. Wakefield © Wessex Archaeology)

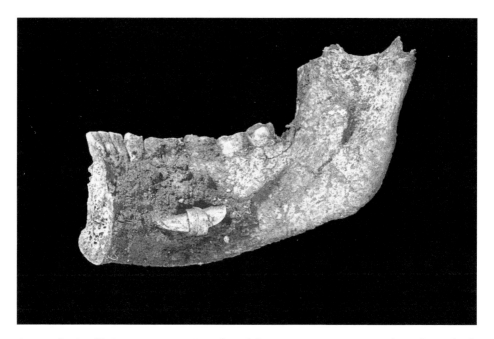

A second pair of hair tresses or earrings, found during post-excavation work on the Archer's companion. It is possible these were on a cord around his neck when buried. (Elaine A. Wakefield © Wessex Archaeology)

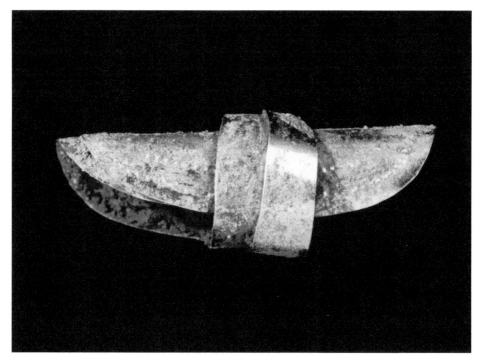

The gold hair tress or earrings found by the Amesbury Archer's knees. (Elaine A. Wakefield © Wessex Archaeology)

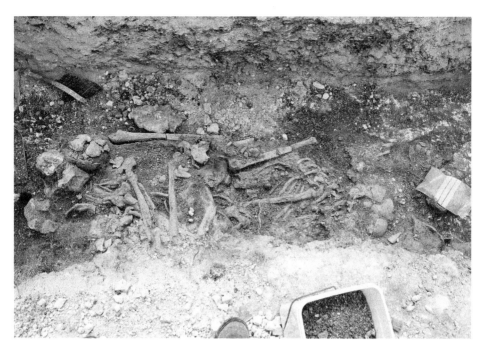

The Boscombe Bowmen. This unusual grave contained the remains of seven people and an unprecedented eight beaker pots. Analysis of the tooth enamel on one adult suggests they originated in the western half of the United Kingdom, possibly Wales. (Bob Clarke)

A Beaker pot associated with the Boscombe Bowmen under excavation. (Bob Clarke)

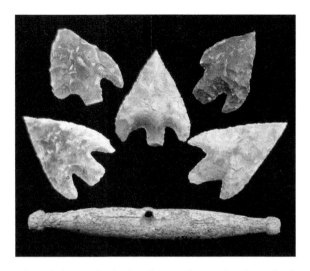 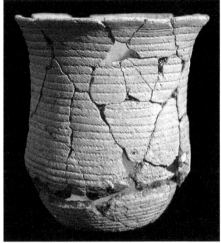

Above left: Five barbed and tanged arrowheads and a fine worked toggle, found during the excavation of the Boscombe Bowmen. (© Wessex Archaeology)

Above right: The same Beaker (*see p. 17*) after restoration by Wessex Archaeology. (© Wessex Archaeology)

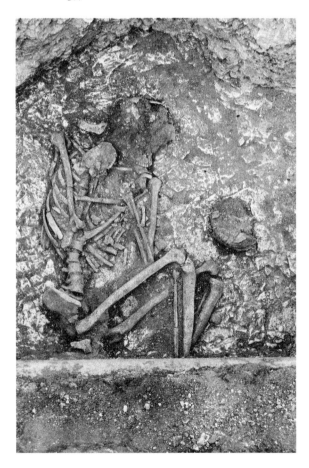

Left: A typical beaker grave at Boscombe Down. This singular crouched inhumation was buried with a Beaker pot – the round object near the knees. (Bob Clarke)

interments, such as those remains located in long barrows, to mostly singular burials in low, circular barrows. It is these Beaker burials that the antiquarians first recognised as something different. Usually, a fully articulated burial, known as a 'crouched inhumation', is buried with a specific cultural assemblage. Often a small metal object, along with a beaker pot, is present. Occasionally, they also have an archer's wrist guards and barbed and tanged arrowheads – finely worked flint again recognised as a cultural marker.

Currently, their influence in the construction of many prehistoric monuments is the subject of major academic debate. Here is just one example that demonstrates the point. In 2003, during preparatory work for a water main at Boscombe Down, QinetiQ site archaeologists noticed what looked like human remains in the side of the pipe trench. Wessex Archaeology was brought in and the site was excavated by Andrew Fitzpatrick and his team. What they discovered was a grave containing the remains of seven people: three adults, one teenager and three children – one a cremation. This was unusual, as Beakers are often singular or occasionally double graves. Accompanying the burials was a fine bone toggle, a boar's tusk fashioned into a spoon, five barbed and tanged arrow heads, and an unprecedented eight beaker pots.

The finds alone make the grave important. However, this importance was brought into sharp focus once radiocarbon dates and a strontium isotope composition of tooth enamel were carried out. Dates placed the burial to *c.* 2300 BC. Suggestively, the teeth returned a result that encompassed a number of western areas, including Wales. Was this group in some way responsible for the Blue Stones at Stonehenge? Well that was the initial thought; it looked like a tangible connection between the Blue Stones from the Preseli Mountains in West Wales and the Stonehenge monuments had at last been found. Three years later, this theory was all but discounted. The Stonehenge Riverside Project was busy revisiting the excavation records of the famous site. What they discovered was that some samples, specifically those from deposits connected with the erection of the Trilithons, had been given the wrong context number. Radiocarbon dates now suggest that the Trilithons and the outer ring of the Sarsen circle date to 2600 – 2400 BC, earlier than the Boscombe Bowmen. And to further confuse the issue, it now seems likely that the use of Beaker-type pottery predates the burial synonymous with the period – the debate continues.

Bronze Age

Throughout the second millennium BC, the agriculture of the landscape reached new heights. New, more efficient, metal tools now drove the clearance of forested areas at an unprecedented speed. Sheep farming became a major part of everyday life, spectacularly demonstrated through the work of Francis Pryor at Flag Fen, complementing the ever-expanding remit of landscape exploitation, thus driving the success of the general population. This is best demonstrated through the increased use of more marginal land – especially on areas now known as Exmoor, Dartmoor and the North Yorkshire Moors. Initially, treatment of the dead followed the earlier Beaker tradition; however, this soon expanded into something far more monumentalised. Huge, circular, earthen mounds were erected over individual burials and cremations. They were so specialised in the south-west that they gave rise to what archaeologists now call the Wessex barrow types. Outwardly, these barrows take a number of specific forms, clearly indicating a level of importance through shapes on the

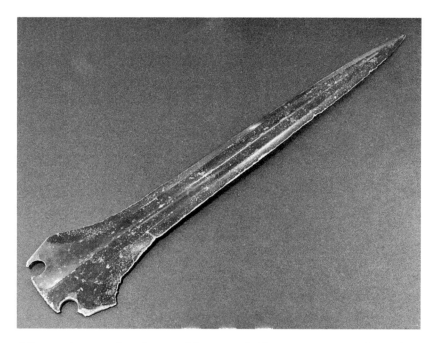

A Bronze Age sword or dagger with a central ridge, two grooves and two rivet holes. Found on Wilsford Down. It is in this period that edged weapons such as this first made an appearance. (Wiltshire Heritage Museum)

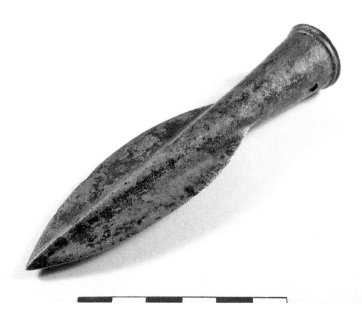

A Bronze Age socketed spear discovered during work on the Melksham bypass. Both this and the sword were cast via the lost-wax technique. A pattern is fashioned out of wax, and then encased in clay, which is, in turn, fired. The wax melts, leaving a void, which is then filled with molten bronze. (Wiltshire Heritage Museum)

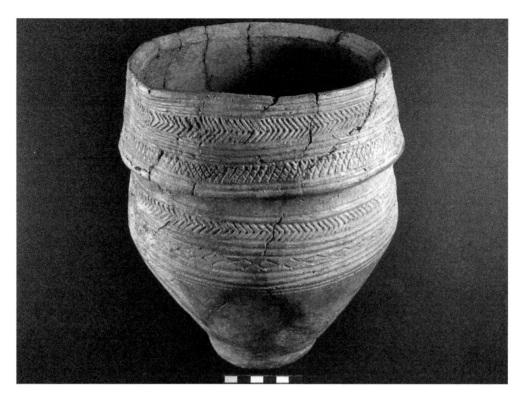

A Bronze Age collared urn, found at the feet of the primary inhumation of the Wilsford G7 barrow, in the Normanton Group. This was also accompanied by gold beads and a grape cup (a small pottery vessel). This is just one example of the fine funerary assemblage now housed at the Wiltshire Heritage Museum in Devizes. (Wiltshire Heritage Museum)

landscape. The extensive cemeteries in the Stonehenge landscape stand testament to that. Barrow cemeteries can be found right across the landscape of the United Kingdom, indeed they are the most numerous of the prehistoric monuments still recognised today.

Interestingly, whilst settlements presumably increase in size, driven by a higher degree of permanency and success, it has become more difficult to recognise them in the landscape. Large swathes of landscape were covered with permanent field systems; Salisbury Plain and the Marlborough Downs have both provided evidence of fairly intensive farming. However, this was not the case elsewhere. The intensification of agriculture, especially on the more acidic geologies, was forcing a crisis by c. 1300 BC. Large areas of upland soil, shallow and already infertile, could not sustain intensive cultivation or even grazing. Then, by c. 1100 BC, there was large-scale abandonment of these areas, and many tracts of upland began to turn into blanket bogs. A number of drivers have been recognised, the primary being the imposition of agriculture on a landscape that could not sustain it. Climate change, probably compounded for a few years by a volcanic episode off the coast of Iceland, appears to have forced the issue. There was mass migration to the lowlands. Heavier clay soils begin to be worked and large boundary earthworks appear, as do some enclosed settlements.

Iron Age

Traditionally, the Iron Age is a period portrayed as being dominated by Celts, of a warlike disposition, who were often covered in woad. Nothing could be further from the truth. The archaeology demonstrates a hierarchical social structure, influencing both the landscape and everyday activities. Wiltshire alone has produced evidence of a people well-versed in agriculture and metalworking. Settlements have been excavated across the county, indicating a complex agricultural system involving grain storage and use, cattle and sheep farming and the emergence of settlements best interpreted as 'large villages'. Indeed, the archaeology from this final millennium BC is dominated by the story of life rather than the monuments of death. In Wiltshire there are substantial examples of hillforts dating from all periods of the Iron Age. As the name implies, these substantial earthworks were once considered to be a product of war.

Fieldwork studies have revealed they perform a number of functions, and it is actually very difficult to prove that a contested landscape, as we would recognise it, was the driver. It is probably more appropriate to consider these large enclosures – sometimes densely populated, other times with only a few houses at the centres – as hilltop enclosures performing a number of functions. The most extensively excavated site in the country at Danebury, Hampshire, has produced evidence of weights and measures systems, salt and metal trading and the storage of hundreds of tons of grain. The enclosures that run along the Ridgeway, including Liddington and Barbury, are more likely to follow this trend; indeed Barbury has produced evidence of that already. We should remember that not every human action leaves behind evidence, some activities can leave fairly ephemeral evidence and others, such as a good conversation, leave nothing at all. However we view hillforts or hilltop enclosures, we must colour them with people carrying out their everyday lives.

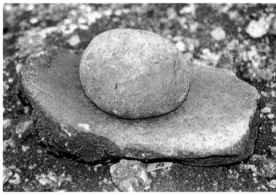

Above: A sarsen quern stone and rubber discovered in a pit at Groundwell Ridge, demonstrating the production of flour on the site, at least for domestic use. (Mark Brace)

Left: Stock enclosures under excavation on Groundwell Ridge, near Swindon. This site is now occupied by the large Motorola factory. (Bob Clarke)

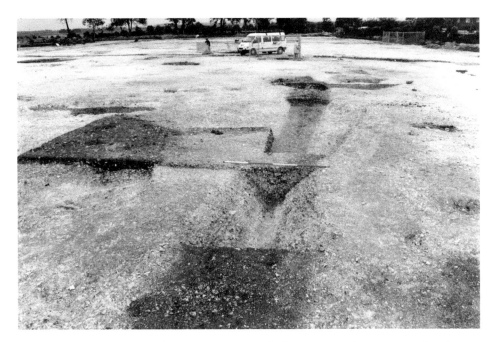

Field Boundaries at Boscombe Down. Iron Age ditches are very diagnostic as they have a distinct 'V' profile. (Bob Clarke)

A two-handled pottery jar, discovered in excavations at All Cannings Cross Farm in 1911. The existence of such vessels proves beyond doubt that a surplus and subsequent storage of many foodstuffs was readily practised during this period. (Wiltshire Heritage Museum)

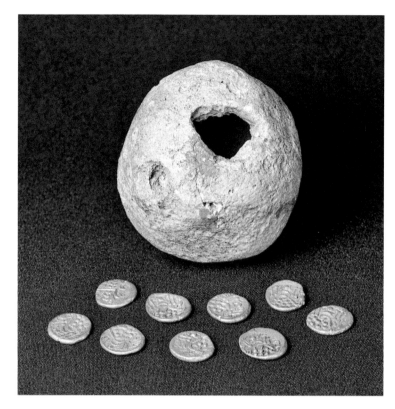

A flint moneybox and nine British gold staters (British Type B) from the later Iron Age period. The flint nodule actually held 100 gold coins when it was discovered in 1994, near Chute. Coinage, as we recognise it, became increasingly used by the Southern Tribes in the century prior to the Roman invasion in 43 AD. (Wiltshire Heritage Museum)

To focus on hillforts is to ignore much of the archaeology that survives across the country. One further monument type is the farmstead. Thousands are known across the landscape, and in some areas these are built of stone with walls surviving to quite a height. Unfortunately, in Wiltshire it is only through excavation that the true complexity of the farmstead is revealed. Two such sites have been investigated to the north of Swindon in recent years. Both sites at Groundwell provided evidence of an advanced agricultural system, with sites storing grain in pits and in granaries. A further multi-phase site was excavated at Ashton Keynes, north of Wootton Bassett, whilst a substantial settlement was discovered during work for a gas pipe at Fighledean a few kilometres from Amesbury. Many more sites are known from cropmarks. So by the time the Romans finally arrive (43 AD) the landscape of England contains a complex agricultural system, topped off with an equally complex political system that has taken at least 4,000 years to develop.

One final point requires expansion - the name Iron Age. This implies a watershed where everyone switches over from using bronze tools to iron ones. Well it is not quite that easy, nor is it safe to suggest such a thing. True, iron tools steadily replace many that were originally bronze, especially those requiring an edge or used to work wood, but bronze in this period actually finds its true 'vocation'. It becomes the artistic medium by which some of the most spectacular metal artefacts come down to us. The Battersea Shield in the British Museum is one such item. Artistic metalwork becomes steadily more influenced by European styles, including gold working and, as a final expression, gold staters, with a ready move to coinage in some areas by the time of the Roman invasion in 43 AD. What follows, as they say, is History.

1

Northern Marlborough Downs

The Marlborough Downs, dominating the north of the County, has a rich archaeological heritage. This record is, however, extensively plough-levelled, save a few round barrows you can see dotted about. Along the northern edge of the Downs runs the Ridgeway, a track of extremely ancient origins, and threaded along that track are a series of Iron Age enclosures.

Liddington Castle

Liddington Castle is located at NGR SU 209 797. The site has no direct access for the public; however, the Ridgeway passes just 200 m to the east of the hillfort.

Liddington Castle is a roughly five-sided univallate site enclosing around 3 hectares. It is situated on the northern escarpment of the Marlborough Downs, with commanding views to the west and north, intervisible with Barbury Castle just over 7 km to the south-west.

Excavation through the ditch in 1976 demonstrated that an initial rampart, supported at the rear by timbers, was remodelled as a dump rampart, which was subsequently increased with a further dump and chalk facing. Pottery suggests the first event to be late Bronze Age/early Iron Age in date, making Liddington Castle possibly the oldest known hillfort site in the county. The site originally appears to have had two entrances; however only the eastern one now remains, the other being blocked in prehistory. A geophysical survey in 1996 revealed an extensively occupied interior, with a multitude of pits along with a number of circular gullies, probably the remains of characteristic round houses. In the fields below, a number of cropmarks suggest the site may have been replaced in importance by a timber palisade; certainly no mid–late Iron Age pottery is known from the site, making this a strong possibility. The excavation in 1976 was primarily concerned with investigating the story that Liddington is the location of *Mons Badonicus* (Mount Baydon), the site of a famous Saxon battle involving King Arthur around the turn of the sixth century AD. Pottery covering the end of the Roman period was located (mid-fifth century), so the proposition that this is the site of *Mons Badonicus* has yet to be disproved – King Arthur, however, remains elusive!

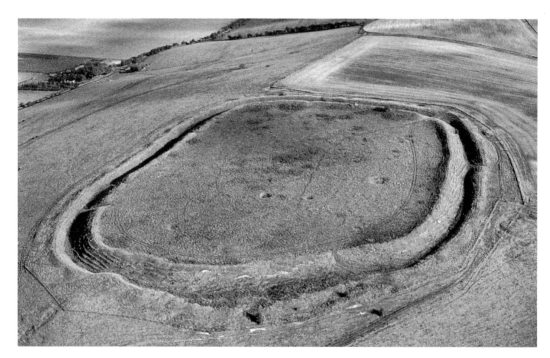

Liddington Castle from the west. Note the circular features inside the earthwork. The blocked western entrance is also indicated by the lump in the outer work (*bottom left corner*). (Bob Clarke & Martin Kellett)

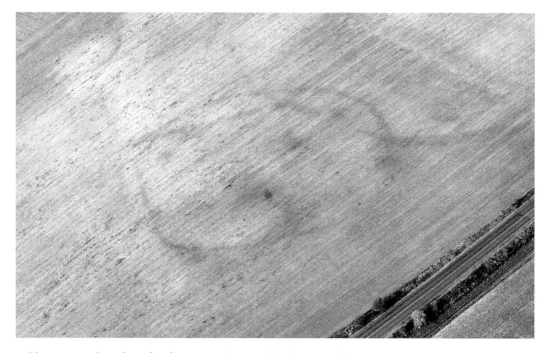

Liddington Castle soil mark. This site is the possible location of the post-hillfort enclosure; it is less than 1 km from Liddington Castle. (Bob Clarke & Martin Kellett)

Barbury

Barbury Castle is located at NGR SU 149 763. The site is signposted from the village of Wroughton, to the north of the site. A substantial carpark and facilities are located 600 m to the east of the monument. The walk to the site is level.

The hillfort of Barbury Castle is situated on the north-facing escarpment of the Marlborough Downs. This large, multi-phase monument encloses nearly five hectares with a bivallate bank and ditch.

In true Iron Age tradition, other sites of a similar age can be seen from Barbury Castle, including Liddington and Martinsell. Cropmarks in the fields below indicate it looked over an intensively farmed landscape. Some damage has occurred over the years. The site has been extensively quarried for flint, and in the Second World War anti-aircraft defences protecting RAF Wroughton were located near the western entrance, necessitating some re-modelling. That said, work by the War Department revealed pits and a number of other features indicative of Iron Age life, including a pottery chronology indicating a long period of occupation.

In 1963, metalwork housed at Marlborough College Museum was published in the Wiltshire Archaeological and Natural History Magazine. It had been donated by the Revd Henry Harris in 1875. Although no details as to the nature of discovery were forthcoming, it is worth mentioning here, as it gave an indication as to some of the activities carried

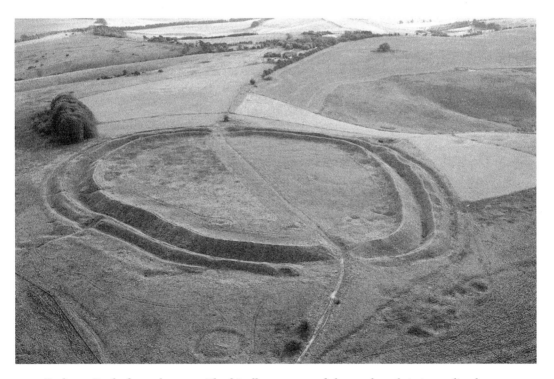

Barbury Castle from the west. The bivallate nature of the earthwork is immediately apparent. Note the earlier Bronze Age disc barrow (*bottom centre*) and the Ridgeway passing through the site. (Bob Clarke & Martin Kellett)

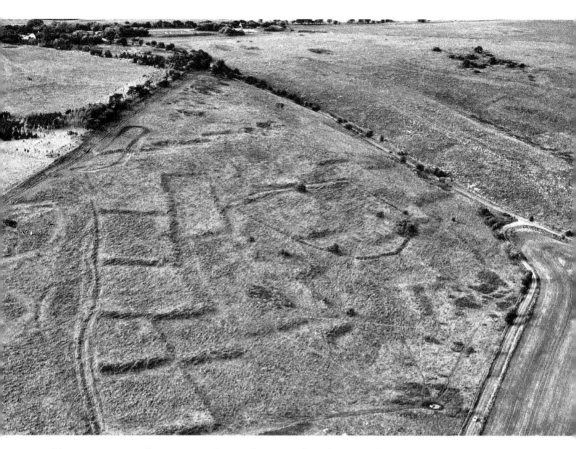

Field Systems on Burdrop Down, 1 km to the west of Barbury Castle. Many of these small fields are contemporary with the hillfort. If you drive to Barbury, these features are on the left as you climb the hill. (Bob Clarke & Martin Kellett)

out at Barbury Castle. The assemblage was dominated by tools, including iron sickles and woodworking awls; however, by far the most important was a singular nave band from a wheel, showing that a cart or chariot was used at the site. Surprisingly, little archaeologically-supervised excavation has taken place on the site. However, in 1996, our knowledge of the enclosure was complemented by a full geophysical survey, revealing that Barbury was densely populated, possibly for five centuries. The survey revealed a landscape of pits, so densely packed that they are difficult to recognise individually, and the possibility of forty hut circles. That said, the monument has not produced late Iron Age pottery, and was probably abandoned in the proto-historic period (150 BC – 43 AD) in line with other similar sites in southern Britain.

The ditch-work at Barbury Castle demonstrates it is a 'developed' site, meaning more than one large bank and ditch enclosing a densely populated area. It is likely that the site was used for a multitude of activities over its lifetime. However, it is certain that agricultural, domestic and probably military functions, connected with both the extensively occupied landscape and the Ridgeway, were key. If you compare Barbury Castle with its neighbour, Liddington Castle, the developed nature of this hillfort becomes immediately apparent.

Ringsbury Camp

Ringsbury is located at NGR SU 085 868. The best way to visit Ringsbury is to park in Dogridge, west of the village of Purton. Then take one of the many footpaths south to Mud Lane. Turn west on the lane to the site. This distance is 1 km and easy, flat terrain. Alternatively, park on Greenhill Lane at NGR SU 075 861, then take the footpath heading north from Greenhill Farm. This route is c. 800 m, but uphill on the way to the camp.

Ringsbury Camp, located between Wootton Bassett and Purton, is a simple multivallate hillfort situated on an outcrop of Corallian Ragstone. The hillfort has an extremely good vista when looking north-west across the Oxford clays to the Cotswolds.

Ringsbury Camp has been, to date, poorly investigated. It was first referenced in Colt Hoare's *Ancient Wiltshire* in 1812, and Maud Cunnington notes the earthwork in *The Ancient History of Wiltshire* in 1938; however, tthere had been little modern fieldwork. The earthworks comprise an outer bank 2 m in height, with a 3-m-deep ditch behind that, followed by a 5-m-high bank. There are two entrances through the earthwork. To the east a causeway has been widened in recent times, making final interpretation difficult. A further entrance to the west appears more likely to be original; however, it too, has been modified recently. The earthworks enclose around 3.5 ha, similar to many other Wiltshire sites that are not considered 'developed'.

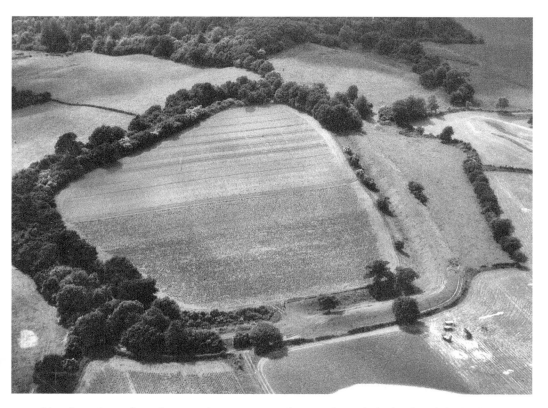

Ringsbury Camp from the east. The entrance can be seen through the bank and ditch. The wooded area contains the most substantial stretches of earthwork. (Wiltshire Heritage Museum)

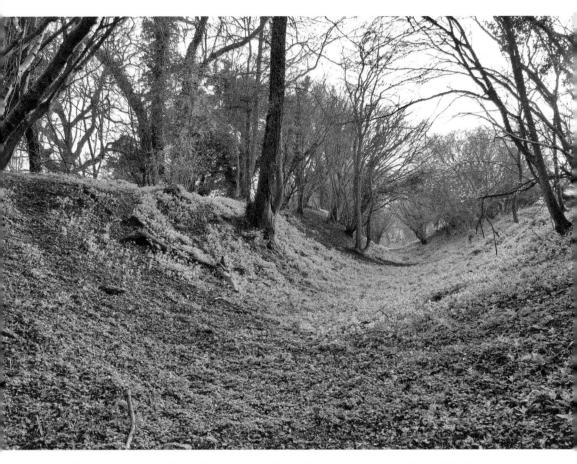

Ringsbury Camp, a view from the central ditch in the southern sector. (Bob Clarke)

Two features to look out for are located at the north-eastern and south-eastern corners of the inner bank. They each have 2-m-high mounds of earth, suggesting some form of observation point. If they are, indeed, contemporary with the Iron Age site, then this increases the provenance of the eastern entrance. Erosion and later quarrying in the southern section reveals something of the construction methods employed in the building of the bank. Demonstrating the antiquity of this section of landscape, a small assemblage of Neolithic worked flint, including a core fragment, scraper, triangular arrowhead and waste flakes, was discovered in the 1980s. More in-line with the hillfort, a gold coin with a blank obverse and a decorated reverse, showing a horse and wheel motif (both are typical of proto-historic 'coinage'), has also been found on the site.

The Avebury Complex

The landscape at Avebury is without comparison. Forming the northern section of the UNESCO World Heritage site, this area comprises monuments from every period of prehistory. However, it is probably most famous for Avebury Henge and Silbury Hill. You can also discover the source of the building blocks of many of the monuments in the area, as many natural sarsens still cover the landscape. A trip to the area is not complete without a visit to the Alexander Keiller Museum, where many of the artefacts from the excavations undertaken over the years are housed.

Windmill Hill

Windmill Hill is located at NGR SU 086 715. The best way to visit the monuments on Windmill Hill is to park in the Avebury National Trust Carpark and then walk through into the village and head west on the High Street. Continue on c.1.2 km then take the track north 1.5 km. This is a steady climb to the monument. The site is owned by the National Trust. Give yourself at least four hours as the site is very large.

Windmill Hill is arguably the most famous of a class of Neolithic monuments called 'causewayed enclosures'. The area around the site has been a popular haunt of flint collectors for at least the past 300 years. The causewayed enclosure was noted by William Stukeley in the early eighteenth century, but it was the excavations of the twentieth century that have opened a window on the use of this ancient site.

Situated on a low hill to the north west of the Avebury complex, Windmill Hill comprises three circuits of interrupted ditches enclosing a total area of *c.* 11 ha. From 1925, for four seasons, the inner and middle circuit of the enclosure were extensively excavated by Alexander Keiller. The finds were copious, including a type of round-bottomed bag-like pottery that became synonymous with many causewayed enclosures across the south-west. The distinctive 'Windmill Hill ware' has now been found in the earliest levels of ditches at many sites, combined with radiocarbon evidence, this suggests that causewayed enclosures were built across Southern England at roughly the same period. Other evidence included large amounts of animal bone, flint and much evidence of feasting through burnt deposits. Keiller revealed

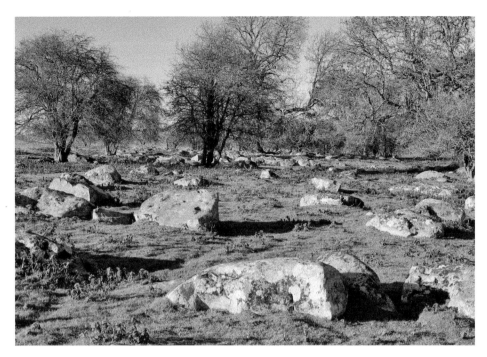

Sarsens survive in great numbers at Piggledean, Valley of the Rocks, just north of the A4, between Avebury and Marlborough. This photograph demonstrates nicely how they got the local name 'Grey Wethers', as they look like a flock of sheep across the landscape. The site is owned by the National Trust. (Alice Clarke)

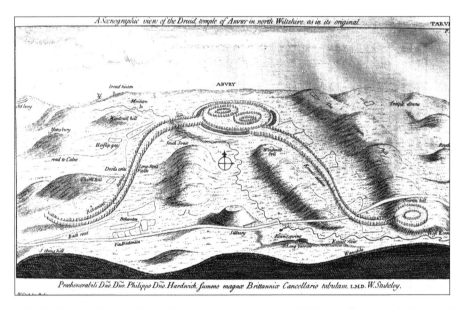

Much of what we know through excavation was recorded by William Stukeley in the early eighteenth century. This illustration shows the Sanctuary, West Kennet Avenue, Beckhampton Avenue, and a number of other monuments, some of which have since been damaged or destroyed. (Wiltshire Heritage Museum)

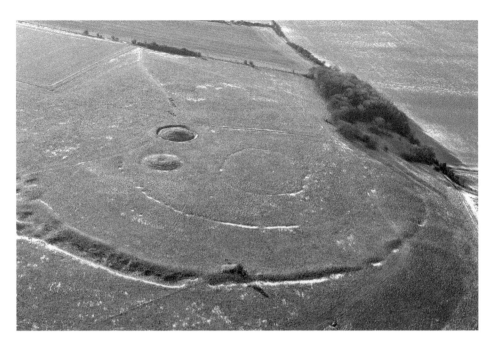

Windmill Hill Causewayed Enclosure from the east. Thanks to a light dusting of snow, it is possible to pick out all three circuits of ditch. The outer circuit, on the left, shows the interrupted nature of the ditches. (Bob Clarke)

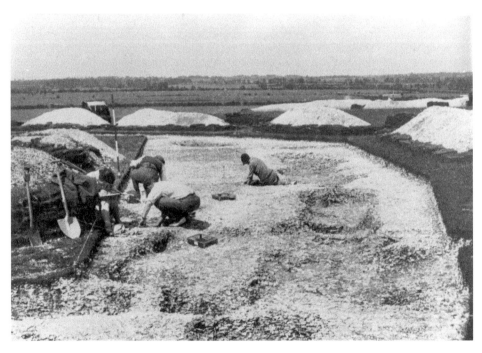

Windmill Hill – excavation of the inner ditch by Alexander Keiller. (Alexander Keiller Museum)

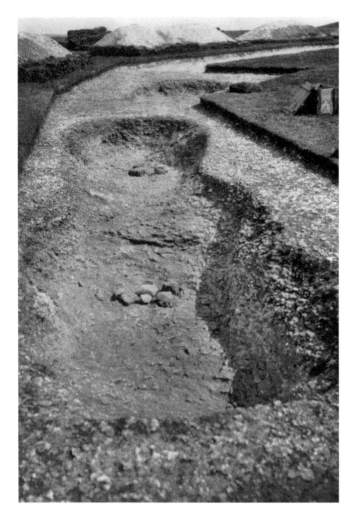

Windmill Hill – one ditch segment on the inner circuit. This shows the unevenness and shallow depth of the ditches – clearly not a defensive structure. Excavation by Alexander Keiller. (Alexander Keiller Museum)

something of the form of the ditch-work, recognising during the work that the interrupted nature of the earthwork was intentional. Unfortunately, Keiller's work was never written up, although during 1957/58 Isobel Smith cut a further five trenches across all three circuits to confirm some of his earlier claims. Underneath the bank of the outer ring, Smith discovered evidence of pre-enclosure occupation. As the outer ditch segments were dug, the material produced was heaped up on the inside of the circuit. In so doing, the original ground surface was buried, sealing in evidence of previous activities. A considerable amount of animal bone, worked flint and charcoal was found – all suggesting quite dense occupation before this part of the monument was built. In the primary silts of all three ditches, Smith located Windmill Hill Ware, which pointed to a roughly contemporary date for all three circuits.

In the late 1980s to early 1990s, work by Alasdair Whittle and Cardiff University sought to obtain secure samples for radiocarbon dating and environmental reconstruction. A number of trenches were placed across known Neolithic features, including one right next to Isobel Smith's early work. This area provided further evidence of the pre-enclosure activity already suspected. The environmental samples point to the enclosure being surrounded by trees, rather

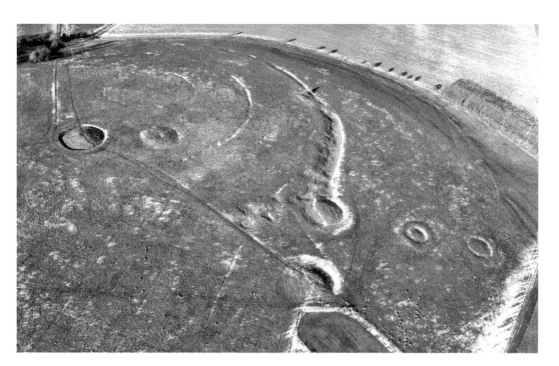

Windmill Hill Barrow Cemetery, taken from the south. The prominent bowl barrow on the left has a deep ditch thanks to Keiller's work in the early twentieth century. The two saucer barrows are on the right of this picture. (Bob Clarke)

than the open landscape we see today. Discoveries of human and cattle bone, in structured deposits rather than just being dumped, add weight to the probability that causewayed enclosures had at least a funerary function. That said, the location of large amounts of pottery, stone tools from other parts of the United Kingdom and charcoal-rich soils suggests Windmill Hill was the focus of many other activities throughout its use.

Windmill Hill Barrow Cemetery

Windmill Hill contains an important barrow cemetery as well as the earlier period Neolithic causewayed enclosure. A dispersed, linear cemetery of at least eight barrows runs across the earlier monument, many incorporated in the later Parish boundary. The original cemetery comprised many more barrows; however, millennia of agriculture have removed quite a number. They are now recognised through cropmarks. Of note is the existence of two of the county's finest saucer barrows. They are located to the west of the outer ditch as the ground falls away.

West Kennet Long Barrow

West Kennet Long Barrow is located at NGR SU 104 677. There is a small lay-by on the southern side of the A4 in which to park, and the barrow is then 700 m up the footpath. The path takes a steady incline once it crosses the River Kennet.

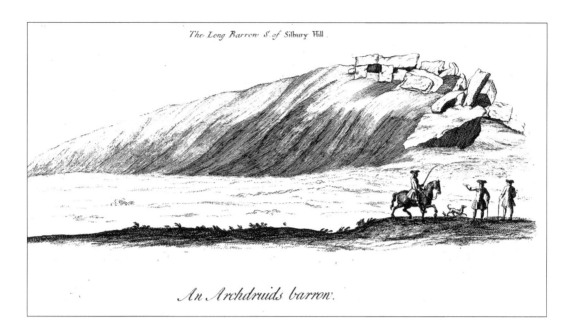

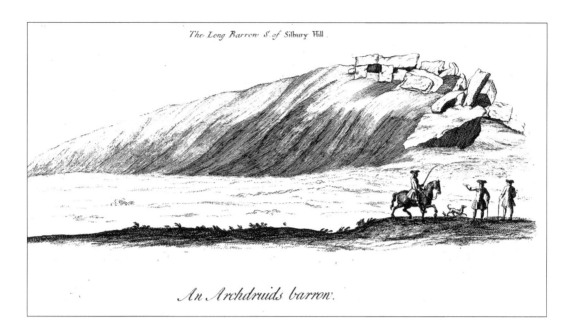

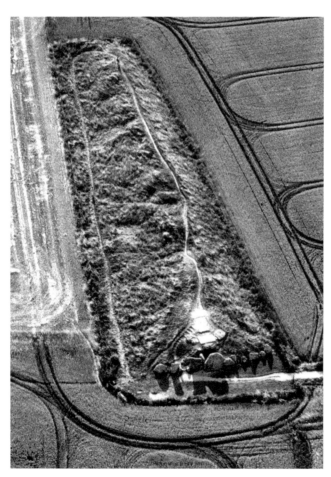

Above: West Kennet Long Barrow, as seen by William Stukeley in 1723. (Wiltshire Heritage Museum)

Left: West Kennet Long Barrow, viewed from the east. The trapezoidal shape of the barrow is noticeable in this picture. (Bob Clarke)

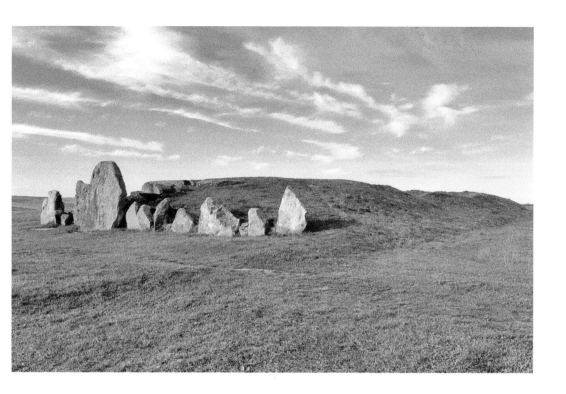

Above: West Kennet Long Barrow is the longest such monument in Britain. (Bob Clarke)

Right: Oolitic dry stone walling incorporated in the barrow's construction suggests connections with groups to the north-west of the site. (Bob Clarke)

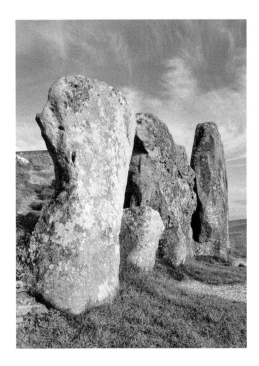

The façade was blocked during the Beaker period by placing massive sarsens, some with axe polishing marks, across the eastern end. (Bob Clarke)

West Kennet is the most famous long barrow in England, containing five stone-built burial chamber following the Cotswold-Severn construction, a type of long barrow widely distributed across the west and north of Britain. The monument is located on a ridge of upper chalk, making the site visible from some distance. The barrow was excavated and subsequently restored for public access during 1955/56.

West Kennet Long Barrow is one of the largest Neolithic long mounds in the country, at just over 100 m. It survives at the eastern end to a height of 2.5 m. The barrow has been the focus of records since the late seventeenth century, when John Aubrey illustrated the site, noting 'On the Brow of the hill, south from west Kynnet [sic], is this monument, but with no name.' William Stukeley visited the site during his investigations of the Avebury landscape, producing three illustrations in 1723/24, noting it as 'The Archdruids barrow'. The majority of features shown by Stukeley were noted in the work 230 years later by Stuart Piggott and Richard Atkinson. In 1859, John Thurnam obtained permission to excavate on the site, however the landowner stipulated he was not to remove any sarsens. As a result, Thurnam had to enter the barrow from the top, where he located the western chamber (at the end to the passage today) and around 5 m of the central passage. Fortunately, he left a number of chambers intact, probably not recognising them as such – leading to the major discoveries by Piggott and Atkinson.

What was discovered in the 1950s can be visited today. The tomb was constructed with five chambers arranged along a 10-m corridor, two lateral chambers either side, and one larger chamber at the western end. All were a mixture of substantial sarsen stones and oolitic limestone walling. The roof of each chamber was corbelled with large capstones, again with sarsens, a number of which are still visible on the surface. The western chamber had been cleared by Thurnam, locating the remains of six individuals in varying states of

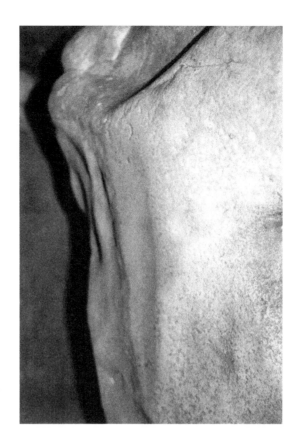

West Kennet Long Barrow axe polishing marks on a sarsen inside the central corridor. (Bob Clarke)

completeness. Piggott and Atkinson discovered that the lateral chambers survived intact. Each chamber contained human remains and early examples of pottery, known now as 'Windmill Hill Ware'. The whole spectrum of life was represented: adults, adolescents, children and infants of both sexes (where recognisable) were present. This small (forty-six, plus six from Thurnam) group had a number of health issues: arthritis, spina bifida, excessive elongation of the head and extra digits, notably toes – were all represented. One adult male, in the north east chamber (first through the entrance on the left), was fully articulated and ominously had a leaf arrow close to his throat. The chambers and corridor had been deliberately filled to the roof with a mixture of chalk and debris, from an occupied site, before being blocked by sarsens. The barrow originally had a large, sarsen-lined and dry stone-walled, crescent-shaped façade, through which the entrance to the chambers passed. This had been finally blocked by the use of several massive stones, a number of which had axe polishing marks on them.

The Devil's Den

The Devil's Den is located at NGR SU 152 696. There are no close parking facilities to the site. The best suggestion is to park beyond the crossroads at Clatford, at NGR SU 161 685, where there is a lay-by. From here it is a pleasant 1.2-km walk to the monument.

The Devil's Den is located in Clatford Bottom, on one of the many routes onto Fyfield Down. The site is something of an enigma, as the validity of the monument's current appearance troubles many academics. The Den was first recorded by William Stukeley in 1723. His illustrations depicted a long mound and a number of large sarsens associated with the structure; however, by the mid-eighteenth century, this had all but been removed. What the visitor encounters today are four large sarsens arranged in a similar fashion to a Welsh 'Cromlech'. Closer inspection reveals the site is actually supported by heavy concrete foundations, work undertaken by A. D. Passmore, one of Wiltshire's early field archaeologists. Conveniently, the date of the restoration, 1921, is inscribed into the foundation. What is visible today is unlikely to be a true representation of the original chambered end of the Megalithic long barrow. Indeed it is described by some as a 'fanciful antiquarian vision'. There is discussion surrounding the actual credibility of the earthen mound too. In 1979, Stuart Piggott stated that, whilst working at nearby West Kennet Long Barrow, two days were spent investigating the suspected forecourt area at the Devil's Den to no avail.

On first inspection, the Devil's Den would appear to be another prehistoric monument that has been Christianised; however, that is not the case here. The Devil's Den more likely takes its name from the earthen mounds, known as *Dillions*, used until the turn of the eighteenth century as boundary markers on the Downs. Indeed Peter Fowler suggested recently that the 'Wiltshire agricultural tongue' was as much to blame as the church for the name!

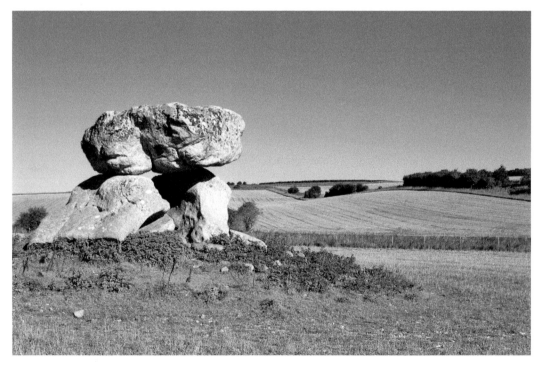

The Devil's Den is located in a small, dry valley, with the flowing Downs as a backdrop. (Bob Clarke)

The *Polissoir* is difficult to find – note the prominent tree and 'pyramid sarsen'. Both are visible to the east of the Ridgeway and mark the location of the stone. (Bob Clarke)

The *Polissoir*

The Polissoir *is located at NGR SU 12840 71513. There are two ways to walk to the site; you can walk up green lane from Avebury, and when you reach the Ridgeway, turn left; or park at the Sanctuary and follow the Ridgeway for 3 km north. Either route you choose to follow will take, in a round trip, two hours. The Sanctuary route is the least taxing. If you take the Sanctuary route, keep an eye on Silbury Hill to the west – the top is visible for 2 km along the Ridgeway, and many consider this to be significant. If you are intending to visit the Polissoir, then use a 1:25,000 map.*

The *Polissoir* on Overton Down is an enigmatic example of Neolithic stone working. The site was first recorded in 1963, although local knowledge undoubtedly knew of the stone prior to that. Indeed, the polishing marks are on the end of a sarsen that has clearly been split, leading Peter Fowler, who has worked on the archaeology of the Downs, to wonder what was on the rest of the stone! This *Polissoir*, whilst impressive, is not unique. A number of sarsens incorporated into other monuments, including Avebury, display areas of polishing. A stone utilised in West Kennet Long Barrow has two areas of polishing, and others were found during the excavation and restoration of the monument. These examples of stone working are thought to date from the fourth millennium BC.

The ground surrounding the *Polissoir* was excavated in 1963 as part of the Fyfield and Overton Down landscape project. Peter Fowler discovered the stone had originally stood upright. Close by, an iron wedge and a half-penny of King John (1197–1206) were discovered. This points to the destruction and subsequent removal of sarsens much earlier than was

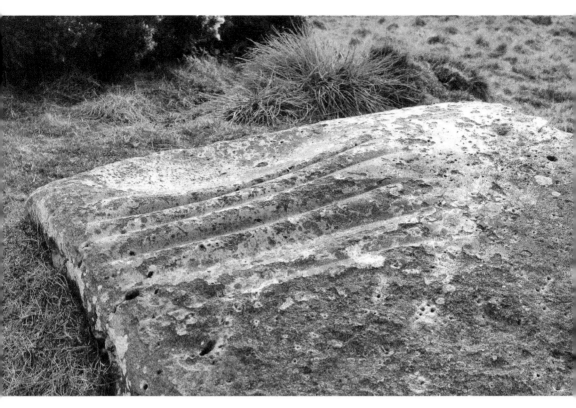

The *Polissoir* places you in direct contact with the act of axe sharpening; both the grooves and dished areas being employed to produce finely shaped items. A number can be viewed in the museum's collection. (Bob Clarke)

currently thought. Considering this, it is highly likely that a number of similar such sarsen polishing stones have been lost in the last 800 years. Recently, Josh Pollard and Andrew Reynolds suggested that the marks could have been formed over generations, the stone being a fixed point in a still-mobile landscape. Whatever the *Polissoir's* purpose and importance to those early societies, a visit to this stone puts you in direct contact with those individuals.

Avebury

Avebury henge enclosure is located at NGR SU 103 700. A carpark is located on the south-western side of the site, and is well signposted. From here, Avebury is just a few hundred metres. Please do not to park in the village, as the congestion is spoiling the setting of the site, along with the quality of life of the locals.

Of all the prehistoric monuments in Britain, Avebury must rank as the most impressive, and when the greater landscape is also considered, this complex is without international parallel. The majority of Avebury henge enclosure survives; it has free public access and is complemented by a well-placed museum and visitors centre.

Avebury henge enclosure is located at the foot of Waden Hill, close to the River Winterbourne.

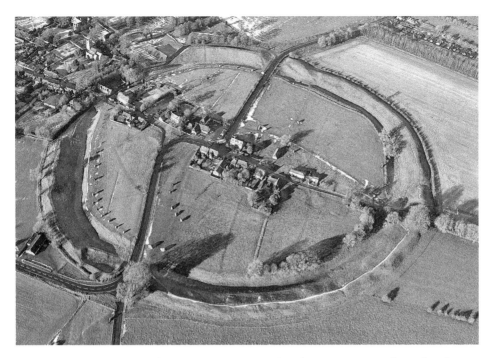

The henge enclosure at Avebury was a massive undertaking. You can see here that the site is rather irregular. The slight dust of snow and low sunlight picks out many of the later medieval earthworks inside the site. This view is from the south-east. (Bob Clarke)

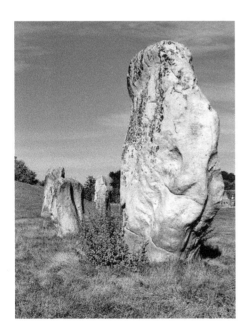

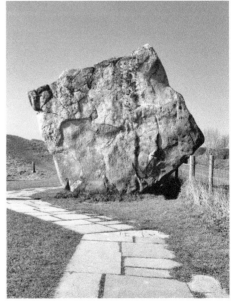

Above left: The Outer Circle sarsens of the south-west quadrant. (Bob Clarke)

Above right: Stone 46, the 'Swindon Stone', in the north-west quadrant. Massive sarsens were used to restrict visibility at the entrances. (Bob Clarke)

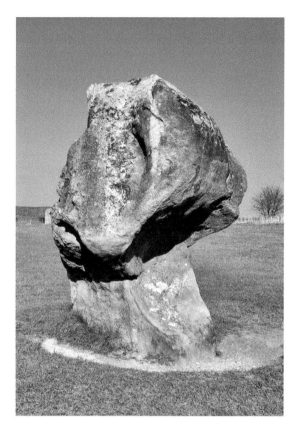

Left: Not all stones were selected for their geometric prowess. Stone 35, in the north-west quadrant, stands testament to that. (Bob Clarke)

Below: The destruction of a stone, on 20 May 1724, recorded by William Stukeley. The stone is toppled into a pit and then heated by fire. It is then doused and hit with sledgehammers. (Wiltshire Heritage Museum)

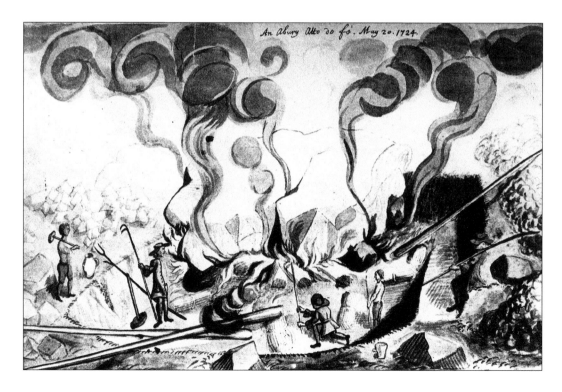

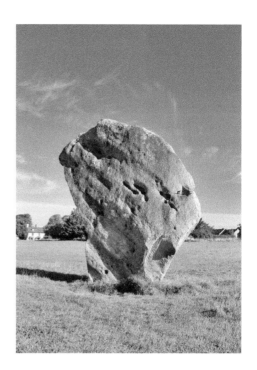

Right: Stone 9, the 'Barber-Surgeon' stone. (Bob Clarke)

Below: Avebury is a huge landscape feature. A later Saxon settlement developed to the west of the site, presumably utilising the prehistoric earthwork as a defensive structure. (Bob Clarke)

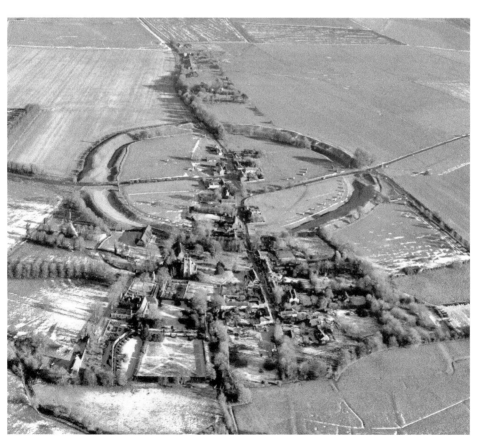

The monument comprises a circular ditch with an external bank, inside which is a stone circle of gigantic proportion, and inside that are two further circles and a number of other megalithic features. The bank and ditch is cut by four causeways, and two stone avenues originally ran from the south-western and south-eastern entrances (discussed in their own sections).

The earthwork surrounding the stone circles was a massive undertaking – remember, at this time there were no metal tools, so all you see was achieved using bones and antler picks. Currently, the ditch survives to a depth of 4–5 m. However, when first dug, it reached between 11–14 m, with a flat bottom and steep, almost vertical, sides. The excavated material was then used to build the impressive outer bank. The undulating top of the bank, although 1–2 m lower than when first built, due to settling, is now thought to be an original feature. The circumference of the monument is an incredible 1 km.

Just inside the ditch stands the largest stone circle in Britain. The Outer Circle includes a number of massive flanking stones at the entrances and shows a level of selection between the four quadrants of the enclosure. The south-west quadrant comprises many irregularly shaped stones, whilst those in the north-west are much more regular and uniform by comparison. A number of smaller features stand inside the Outer Circle. Slightly offset from the north-west/south-east entrances are two further stone circles, each around 100 m in diameter. Inside the northern is a feature known as the Cove. Two stones now stand here, a third has been destroyed. The feature originally opened to the north-east – its function is still debated. The Cove does, however, allow us the opportunity to investigate something of the nature of construction at Avebury. When, in 2003, stabilisation work was begun, the largest of the two stones was discovered to be at least 3 m underground, giving it a weight in excess of 100 tonnes! This indicates the stone was lying here naturally, giving rise to the thought that many of the large stones may have occurred within the immediate area and may drive the slightly irregular shape of the enclosure.

The southern circle also contains other features, including a series of red-coloured, smaller sarsens. It was also the location of the Obelisk, a monolith over 6m high, recorded by William Stukeley in the early eighteenth century. The site is now marked by the large concrete feature. A large number of stones have been destroyed, especially throughout the eighteenth and nineteenth century. Indeed, Stukeley recorded the process in 1724. The site attracted a number of investigations throughout the twentieth century, the most famous and probably most controversial being the work of the marmalade millionaire – Alexander Keiller. For a five-year period, immediately prior to the outbreak of the Second World War, Keiller embarked on an ambitious plan to restore the entire monument. He worked on the north-west and south-west quadrants, as well as the first stretch of the West Kennet Avenue. Much of what we see today is the product of that period. Keiller encountered a number of destruction pits, placing small concrete markers where the stone once stood. He also set about removing houses from within the enclosure; a number of house platforms are visible, especially around the Cove.

Whilst working on the buried stone 9, in the south-west quadrant of the outer circle, the team discovered skeletal remains under the sarsen. He had been trapped under the stone as it had fallen, and no attempt had been made to retrieve his body. Luckily – but not for him – he had a number of coins dating 1320-1350 by his side. He also had a pair of scissors and a probe or lance, both tools of the 'Barber-Surgeon' and the name stuck. It is highly possible he was working on the burial pit when the sarsen fell on top of him. His tools are now on display in the museum.

46

As with any monument of this size and complexity, interpretation and dating becomes increasingly difficult. It is probable that the enclosure dates to the middle of the third millennium BC, as a radiocarbon date from the ditch suggests 2900–2600 BC. Surprisingly, little material has been located with the stone settings, but on analogy with the Avenues may date to *c.* 2400 BC. Optically Stimulated Luminescence – a form of dating process – suggests the Cove was constructed at the end of the fourth, beginning of the third millennium BC, contemporary with the earthwork. As to the function, the site clearly works on a process of visibility. There are restricted views through the large stones at the entrances, and restricted access imposed by the massive ditch. The bank was the probable vantage point from where all activities in the centre stone settings were observed. Whatever its function, Avebury and its surrounding landscape is a must for the prehistoric visitor.

Beckhampton Avenue

Adam and Eve are located at NGR SU 089 693. It is possible to walk to the location from the bottom end of Avebury village. Follow the path out to Avebury Trusloe and then continue west along South Street. The total distance is 1 km.

Two standing stones near the A4 are over one kilometre to the west of the main Avebury monument, hinting at solitude. Even the names, Adam and Eve, suggest just this pair and no more. All that changed in 1998, when a multi-discipline archaeological team made some important discoveries.

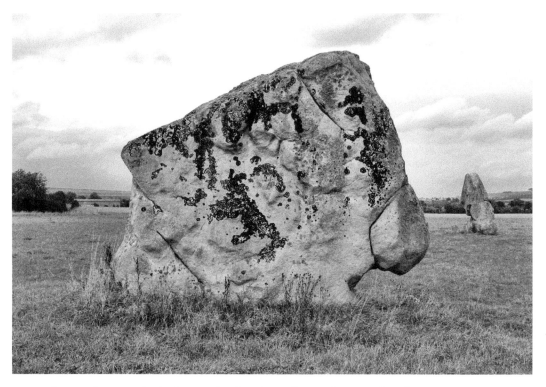

Adam, with Eve in the background. Adam formed part of a cove when first erected, whilst Eve is the last remnant of the Beckhampton Avenue. (Bob Clarke)

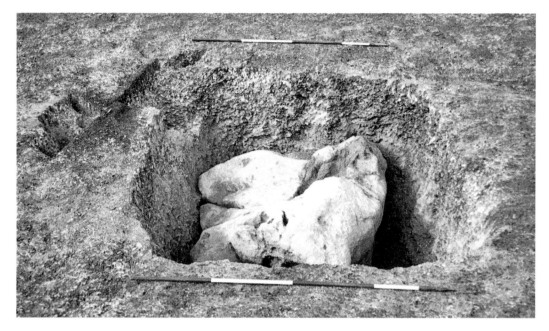

C4 stone burial pit F. 26. To the left of the stone, you can see the original socket it occupied. The pit the sarsen lies in is very carefully cut to mirror the shape of the stone. (Longstones Project via Josh Pollard)

The existence of the Beckhampton Avenue had been hotly debated until, in 1998, a team comprising a number of universities set about proving once and for all that there was more to Longstones Field than just Adam and Eve. William Stukeley had, in 1724, illustrated at least the remnants of a full stone avenue running west from the great henge, but since then it had become almost trendy to refute his suggestions. What was discovered proved that Adam and Eve are, indeed at the end of a major lithic avenue that in all probability runs from Avebury. The larger of the two remaining stones, Adam, appears to have been part of a cove facing south-east. Eve, on the other hand, once formed part of the avenue that ran to the cove. Along the suspected route of the avenue, the team discovered a number of destruction pits and, probably more importantly, a number of buried stones. The practice of stone burial appears to have been a short-lived episode from the early fourteenth century. Pits were cut to mirror the stones' shapes, and then it was toppled in and covered. The team also located an earlier, oval enclosure, radiocarbon dating providing a construction date range of 2820–2660 BC. It appears this earlier enclosure may have been filled in prior to the construction of the avenue and cove.

West Kennet Avenue

The West Kennet Avenue starts at NGR SU 103 698 and originally continued on to the Sanctuary at NGR SU 118 679. The best way to visit the site is to include it with your visit to Avebury Henge enclosure. The section nearest Avebury is the only visible section; there are a few stones as you travel south but the majority have now been removed.

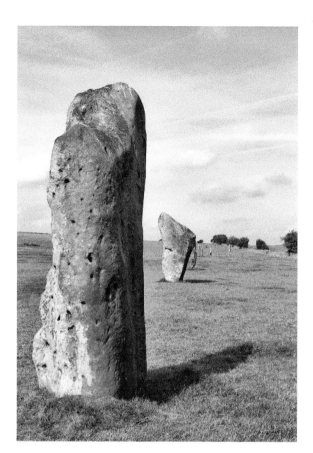

Right: View of the West Kennet Avenue, from the south-east, looking up towards the Avebury monument. (Bob Clarke)

Below: A postcard showing the 'Remains of Druids Stone Avenue', prior to restoration by Alexander Keiller. Note that just one stone is standing in this section. The view is looking towards the south-east. (Bob Clarke)

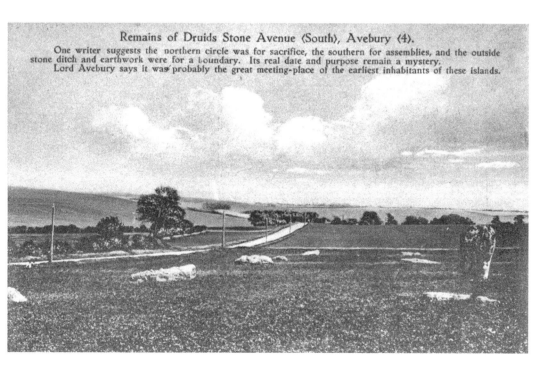

Remains of Druids Stone Avenue (South), Avebury (4).

One writer suggests the northern circle was for sacrifice, the southern for assemblies, and the outside stone ditch and earthwork were for a boundary. Its real date and purpose remain a mystery.
Lord Avebury says it was probably the great meeting-place of the earliest inhabitants of these islands.

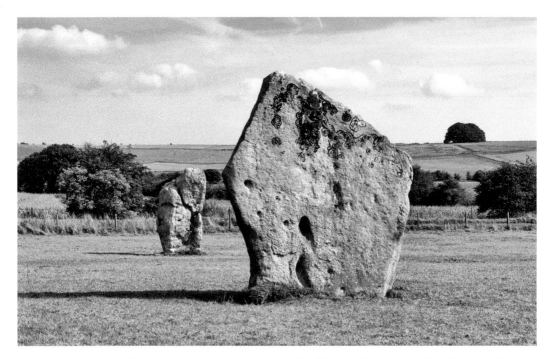

There is a suggestion that the Avenue stones were specifically paired, as seen in this photograph. Unfortunately, not all conform to this. (Bob Clarke)

The West Kennet Avenue runs from the south-eastern entrance of Avebury Henge 2.4 km to the monument known as the Sanctuary on Overton Hill.

The West Kennet Avenue is a double stone row that originally covered *c.* 2.4km, its terminal being the Sanctuary. Today, the monument appears to end abruptly after 800 m; however, geophysical work has proven that some stones lie further on, being the victims of the stone buriers of the fourteenth century. This Avenue was the scene of some of Keiller's restoration work; one stone has a brass pin supporting it, whilst other, now-empty stone sockets are indicated by the low, concrete obelisks, symbolic of the work in the 1930s.

Originally, over 100 pairs of stones would have stood 15 m apart and set between 20–30 m. All were undressed and naturally surfaced; however some level of selection is suggested. Many of the pairs appear to follow a set form – one large rounded stone and one slender tall stone, leading some to speculate a level of gender in the landscape.

The Sanctuary

The Sanctuary is located at NGR SU 118 679. There is a carpark on the opposite side of the main A4 Calne – Marlborough road. Please be careful when crossing this road.

The Sanctuary is a stone and timber monument located on Overton Hill to the east of Silbury Hill. The site is inextricably linked to the stone circles at Avebury via the West Kennet Avenue. The site was substantially investigated in the 1930s and has recently benefited from further work.

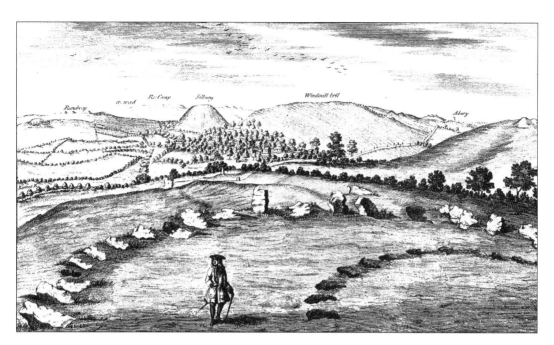

'Prospect of the Temple on Overton Hill 8 July 1723'. William Stukeley's representation of the Sanctuary. Note the Avenue running away from the site, and Silbury Hill in the distance. (Wiltshire Heritage Museum)

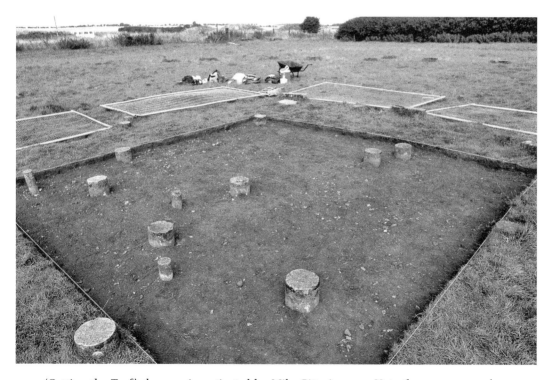

'Cutting the Turf', the area investigated by Mike Pitts in 1999. Note the concrete marker posts suggest one phase of construction. (Mike Pitts)

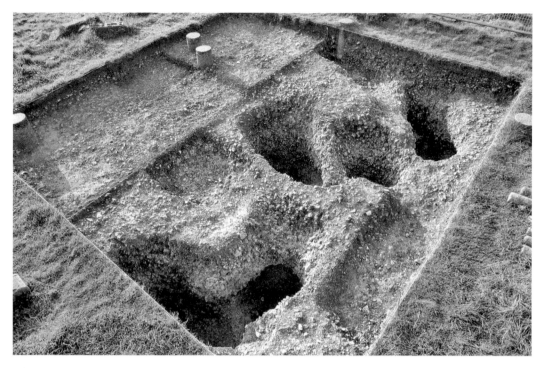

'The Sanctuary Revealed'. Compare this with the previous photo. The complexity of the monument's structure is clear. (Mike Pitts)

The Sanctuary was first noted by John Aubrey in 1648, but it was left to William Stukeley to describe the site in detail and record the site's name, as used by the locals. Stukeley recorded the destruction of the two concentric rings of standing sarsen stones to 'gain a little dirty profit' in the winter of 1724. By the end of the century, the exact location of the site had been lost due to the continual ploughing. Surprisingly, Stukeley left later generations a clue. He considered the main lithic monuments at Avebury were laid out as a giant serpent, with the Sanctuary representing the head. He noted that the head could be seen from the tail, on the Downs, near Beckhampton, 4 km to the west. In 1930, the Cunningtons, having just finished the excavations at Woodhenge, went in search of the Sanctuary. Using Stukeley's description, they located not only the two circles of vacant stone holes but a further six rings that once contained timber posts. During the 1930 excavation, a Beaker burial was recorded; further, the site was suggested to comprise a timber monument followed by a lithic one and it was not thought the timber posts supported any type of roof. Since then, the function and nature of the site have been fiercely debated by the archaeological community. Everything from a series of roofed, circular buildings of varying circumferences, to a timber and stone circle utilising all the sockets has been offered.

In 1999, Mike Pitts, using the diaries of William Young, the foreman of the 1930 excavation, re-investigated the site and in so doing opened a new window on the Sanctuary's construction and use. A number of post-holes were re-excavated, revealing a series of post-pipes rather than just singular events. Further, it is likely that posts were removed and reset across very short time periods, making the Sanctuary a site of physical mobility, probably changing appearance

on a seasonal basis. This is a radically different interpretation to the static, roofed building proposal that often surrounds the timber circles debate.

Silbury Hill

Silbury Hill is located at NGR SU 100 685. There is no public access to the monument or its surrounding ditch. That said, there is a car park and viewing point a few hundred metres to the west that can be accessed from the A4. Silbury Hill is best observed from a distance, as only then can the true enormity of the prehistoric civil engineering task be fully appreciated.

Silbury Hill is the largest known man-made mound in Europe. It is surrounded by a number of major prehistoric sites, including the Avebury complex and West Kennet Long Barrow. The mound comprises mostly chalk, excavated from the surrounding ditch. It has been the focus of many investigations in the last 250 years – the most recent connected with a major conservation effort by English Heritage in 2007/08.

Silbury Hill is, according to recent work, 150 m in diameter and reaches to a height of 31 m. The base is not circular; rather it appears to have been laid out over a series of spokes, as it has nine discrete sides. The monument first appears in written accounts *c.* 1545 by John Leland, and later in William Camden's work in 1607. However, it was reported in 1663, after a visit by John Aubrey, accompanied by Charles II, that the monument began to receive attention. Stukeley noted the planting of trees on the site in 1723, along with the discovery of a burial and some iron artefacts. In 1776, one Colonel Drax, under the patronage of the Duke of Northumberland, set about discovering what lay at the centre of the hill. Using a team of Mendip miners, he sunk a shaft from the top of the mound to the base, recording little on the way. It was this shaft that collapsed in 2000, prompting nearly a decade of modern archaeological work on the site. In 1849, the mound became the focus of the Archaeological Institute who occasioned the cutting of a tunnel from the south-west, this time to follow the approximate ground surface. This tunnel was re-opened in 1968, when, together with a large film production unit, Professor Richard Atkinson conducted a series of live investigations for the BBC's archaeology programme *Chronicle*. It was not until 2000 that more work was undertaken, this time aimed at conservation rather than investigation.

The most recent work on Silbury Hill has spanned nearly a decade. When, in 2000, the shaft dug by Colonel Drax collapsed – first just the original diameter of the feature but soon opening to a 7-m crater – it was clear the monument was in danger. Survey work throughout 2001 discovered a number of voids in the structure, primarily caused by the inadequate back-filling of previous investigations, including the BBC work. By 2006, an ambitious plan had been made that would ensure the monument's future, and for the first time properly record as much of the structure as possible. The work took a year, running from May 2007 – May 2008, after which the monument was sealed and consolidated. Over 1,460 tonnes of chalk were used to fill the voids and crater that first warned the archaeological community that all was not well with the monument.

The results were spectacular, challenging practically every aspect of perceived knowledge about Silbury. Atkinson recognised three possible periods of construction; Jim Leary of English Heritage recorded fifteen Neolithic phases along the route of the old tunnels alone, and more are probable under the areas not investigated. The central feature of Silbury comprises a low, one-

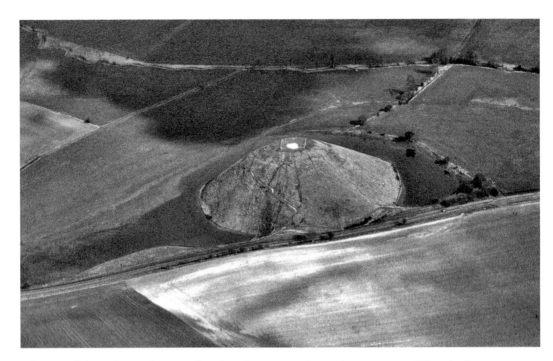

Silbury Hill from the south-west. This shot, from 2002, shows the temporary filling in the crater at the top of the monument. It also shows the extent of the surrounding ditch, as it is close enough to the water table to fill when the weather is bad. (Bob Clarke)

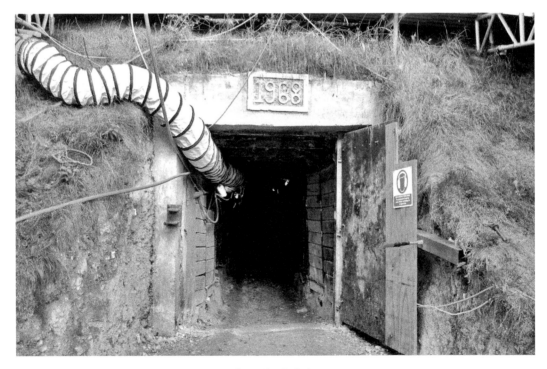

The 1968 'Chronicle' entrance to Silbury Hill. (Bob Clarke)

The 1968 tunnel. The steel supports were installed by students of Cardiff University. The old ground surface can be clearly recognised. (Bob Clarke)

The original mound at the centre of Silbury Hill. It is possible to recognise deposits of gravel and turves in its make-up. (Bob Clarke)

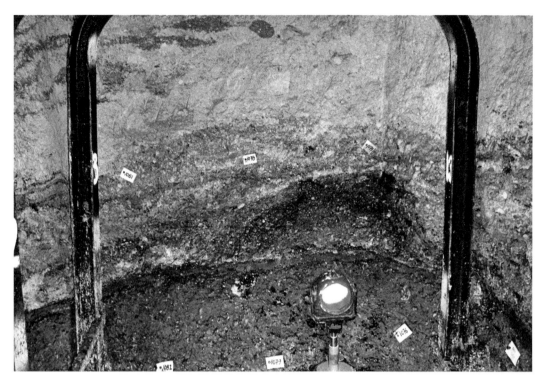

A small pre-Silbury feature at the end of the eastern lateral chamber. (Bob Clarke)

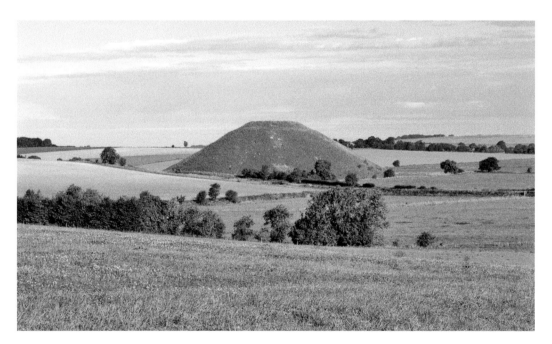

Whilst Silbury Hill might be the largest man-made mound in Europe, it is placed at the lowest point in the valley. Clearly, visibility was only partially the reason for its construction. (Bob Clarke)

metre-high mound, around ten metres in diameter. The mound consisted of gravel, turf, chalk and clay with flint. Other smaller mounds were constructed using material probably brought from further afield. The central feature was then covered over by a further few metres of mixed material and sarsen stones. This was, in turn, surrounded by a substantial ditch with an inner bank. Leary suggests the site should be considered an enclosure at this time. Throughout the Neolithic, a number of mounds were imposed on the site, finally presenting the shape we see today. At the time of writing, the post-excavation work was continuing, and initial radiocarbon dates point to the early phases occurring around 2400 BC.

The Marlborough Mound

The Marlborough Mound is located at NGR SU 183 687. The best way to view the Mound is to park in Marlborough High Street and then walk out towards Avebury on the A4. Around 400 m past the college is a footpath south to Preshute House. Follow this round to the east where it passes close to the monument. To the south, the Marlborough White Horse can also be viewed. Note there is no direct public access to the Marlborough Mound.

The Marlborough Mound is, in my view, a classic example of the debate that surrounds the origins of much of British prehistory. I had mused whether to include this site or not, after a review of all the current papers on the subject and comments from a number of key archaeologists; however, it became clear that this site simply had to be included.

The Mound is situated on the valley floor just 200m from a substantial bow in the River

The Marlborough Mound from the South. The Mound (*centre, covered in trees*) now sits in the middle of Marlborough College. Its provenance is still much debated. (Bob Clarke)

Kennet. It has a circumference of 83 m, and is raised to a height just short of 20m. The question is, is the Marlborough Mound another example of a monumental mound, similar to that found at Silbury Hill, 8.5 km to the west, or was it built in the late Norman period as a component of Marlborough Castle? No true excavation has been undertaken, and the finds are subjective. The Mound has been much remodelled in history. It was certainly used as the motte mound of Marlborough Castle, the earliest mention being 1139. It was utilised during the Civil War, a spiral walkway was cut in the later seventeenth century, and a number of grottoes were dug into it. By the eighteenth century, the summit contained a pond and summer house, eventually replaced by a water tank. When this was again replaced in 1912, the opportunity was taken to investigate the site. A section was cut across the base of the mound, revealing a chalk rubble dump on an original ground surface. The finds were sparse, nearly all being confined to Norman pottery; however, a number of red deer antler fragments were located (now lost). These could be digging tools indicative of Neolithic construction techniques, or they could be the remnants of a hunting trip in Savernake Forrest. The debate rumbled on! Then in May 2011, whilst this book was still in draft form, four radiocarbon dates from sample placed the mound in the late Neolithic (*c.* 2400 BC). Clearly the well-explored landscape of Prehistoric Wiltshire still has much to offer.

Oldbury

Oldbury hillfort is located at NGR SU 049 693. The best way to experience this multi-phase landscape is to park at NGR SU 077 693 located on the A4 then walk the Old Bath Road onto Cherhill Down. The walk is a total round-trip of 7 km from this carpark. For just the hillfort, park along the A4 at NGR SU 041 701 near the village of Cherhill. The walk from here is 800 m but very steep.

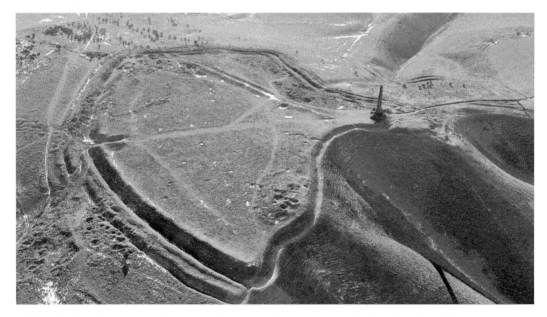

Oldbury hillfort from the north. Many of the internal features are highlighted here by a light dusting of snow. Note the intern banks guarding the entrance to the site from the east. (Bob Clarke)

Left: Cherhill Down. The route of the old Bath Road. (Bob Clarke)

Above: Cherhill Down. This large barrow was dug in the eighteenth century. Unfortunately, no record of the content could be located. (Bob Clarke)

Oldbury hillfort, above the village of Cherhill, is a substantial, multi-phase, site. It has some spectacular surviving earthworks, coupled with a number of linear ditch and field systems in the local landscape. The defensive works enclose an area of 9 ha and are a complex mix of periods probably covering the last 500 years of the first millennium BC. There are extensive views from the site. To make the most of a visit to Oldbury at least three hours is advisable.

The site has seen little recent excavation. However, William Cunnington noted a number of pits containing early haematite pottery and animal bone, 'the certain marks of habitation' when observing flint digging. As with other monuments of this period, there is evidence of two entrances, both with interned earthworks. The one to the east appears to have remained in use throughout the site's occupation, protected by a complex series of earthworks and providing access from the easier direction of approach. The second has been substantially damaged by the construction of the Lansdowne Monument. The hillfort has recently benefited from a substantial and detailed period of field survey. Geophysical work has revealed a site that has seen many periods of occupation and remodelling. In the northern sector, an interrupted ditch encompassed at least sixteen round houses, a number still visible as slight earthworks today, and possibly four post structures (granaries) and pits. The survey also demonstrated evidence of habitation in other areas; unfortunately, flint and chalk digging from the eighteenth and nineteenth century has substantially removed any chance of recognising Iron Age features on the surface here.

The surrounding landscape is truly multi-period. In the fields to the north of the track stood RAF Yatesbury, a substantial First World War and later training station. A number of buildings survive, including some First World War hangars and the station gymnasium, now standing alone in a field. Further along the track is a large, round barrow, with an observation point built in the top. To the south, and running parallel to the track, is a substantial linear ditch. As the track turns south around a large bowl barrow, it crosses the ditch, to the left as you approach the climb to the hillfort. It can be seen running east as an upstanding earthwork; however, the section to the west that ascends Cherhill Hill is ploughed out but does appear as a grass mark, particularly visible in winter or the dry conditions found in summer.

3

The Vale of Pewsey

The Vale of Pewsey at sunrise. (Bob Clarke)

The Vale of Pewsey has, until recently, been considered a bit of an archaeological backwater. Recent work has now started to demonstrate its importance in the late Bronze/early Iron Age. It is home to Marden Henge, the largest in Britain, and a number of other, plough-levelled Neolithic monuments. The chalk downs on the north side of the valley feature a number of impressive monuments, and equally impressive views.

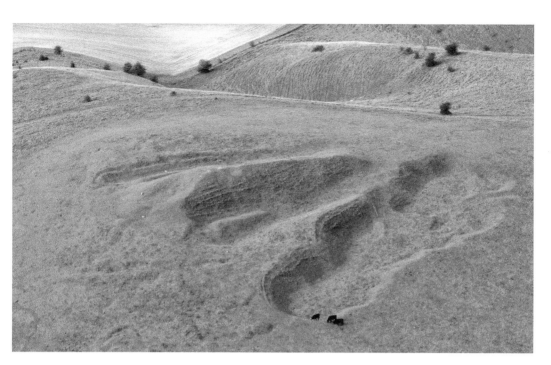

Adam's Grave Long Barrow from the east. The trapezoidal shape of the monument becomes apparent when viewed from the air. The ditch to the right has been substantially extended by later flint quarrying. (Bob Clarke & Martin Kellett)

Adam's Grave Long Barrow

Adam's Grave is located at NGR SU 112 634. Parking is provided for this site and Knap Hill at NGR SU 116 637. The walk to Adam's Grave becomes increasingly steep, especially the last 200 m; however, the rewards of the view alone makes the effort worth while.

Adam's Grave long barrow provides the visitor with one of the finest views in the County of Wiltshire. Standing on the summit of Walker's Hill, the constructors of this Cotswold–Severn-type barrow clearly intended the monument to be seen.

The long barrow is orientated SE–NW, has two deep flanking ditches, and demonstrates the classic trapezoidal shape associated with the majority of this type of monument. The remnants of a chamber and possible forecourt are clearly visible at the south-eastern end of the mound. This area was excavated in 1860 by local antiquarian John Thurnam. He discovered human remains and a leaf-shaped arrow head, indicative of Neolithic flint working. There was also evidence of oolitic limestone used in the construction of the chambered end as with West Kennet, 4 km to the north. It is possible that the spur Adam's Grave stands on was originally segregated from the rest of the landscape by an interrupted cross dyke, visible 300 m to the north of the barrow. Naturally, such a prominent prehistoric feature has appeared in historic texts. By the sixth century, the barrow was known as *Wodnesbeorg* (Woden's Barrow) and may have been the scene of two battles, one in 592 and a more likely action between the West Saxons and the Mercians in 715.

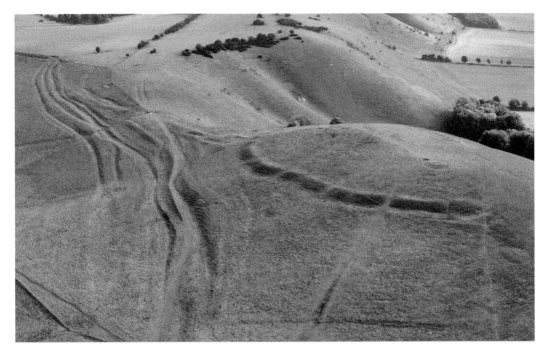

Knap Hill Causewayed Enclosure from the north-west. The distinctive, segmented ditch-work was the first clue to the site being older than the Iron Age. The tracks to the left are multi-period, probably spanning prehistoric to post-medieval times. (Bob Clarke & Martin Kellett)

Knap Hill

Knap Hill is located at NGR SU 121 636. Parking is provided for this site and Adam's Grave at NGR SU 116 637. The walk to Knap Hill is around 500 m, with a steady incline past the end of the carpark.

Knap Hill Causewayed Enclosure was the first interrupted ditch monument in the United Kingdom to be recognised – now over seventy of these extremely early sites are known. The enclosure is located on the northern edge of the Vale of Pewsey. The underlying geology is chalk, with a cap of clay with flints on the top of the hill. As with Adam's Grave Long Barrow, a few hundred metres to the west, there are spectacular views across the Vale of Pewsey and onto Salisbury Plain.

Knap Hill has seven recognisable segments of ditch that partially enclose the hill top. The fact that this circuit is incomplete suggests the monument was intended to be visible from the North and the West. The site has seen two excavation campaigns, both in the twentieth century. Between 1908 and 1909, the Cunningtons cut a trench across the bank and ditch in order to 'ascertain, if possible, the period to which the entrenchment on Knap Hill belongs'. What they found, specifically at the north-eastern end, on a small plateau, was a multi-phase site utilised in the Iron Age, Roman and seventeenth century. A cutting through the causewayed ditch demonstrated a site 'of very great antiquity'. In 1961, Graham Connah reinvestigated the site, bringing a much more critical eye to the proceedings. Neolithic pottery of a known type (Windmill Hill) was found in the primary silts and under the

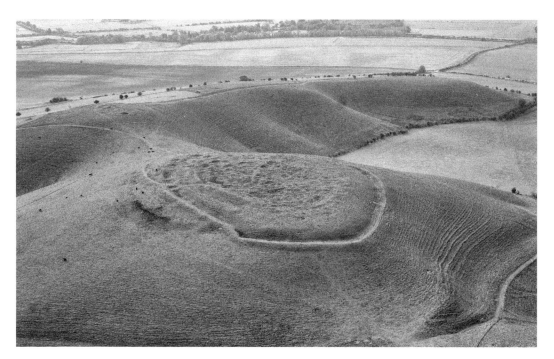

Rybury Camp from the north-east. From left to right: the exposed soil lines the top of the Neolithic earthwork, the bank and ditch of the Iron Age site, followed by the disturbance of the flint diggers. (Bob Clarke & Martin Kellett)

bank of the causewayed enclosure, indicating at least a third millennium BC origin for the location. That said, generally there was little evidence of occupational debris, pointing to a site with a special use rather than day to day activities. A number of Bronze Age barrows are also located on the hilltop; the one visible in the south-western end of the enclosure was excavated by John Thurnam in the mid-nineteenth century. He found a circular cist cut into the chalk and filled with cremation material.

Rybury Camp (Neolithic and Iron Age)

Rybury is located at NGR SU 083 640. Visiting Rybury requires a level of stamina. It is possible to park at Cannings Cross Farm at NGR SU 078 632 or in the village of Allington at NGR SU 068 631. From Cannings Cross Farm the site is 1 km north-east with a steady incline for the first 700 m before a climb of 70 m to the camp itself. If walking from Allington, add a further 1 km of steady incline.

Rybury Camp is located on the chalk massif that forms the northern edge of the Vale of Pewsey, on a spur that forms a large natural combe to the east. A further 300 m to the south a small knoll, Clifford's Hill, also displays evidence of earthworks. Rybury Camp is set within a multiphase landscape, many linear ditches and round barrow cemeteries of the Bronze Age intermingle with a number of long barrows and features of later, historic, origin. The climb onto the monument is steep, but the visitor will be rewarded with some

spectacular views across the Vale to the northern scarp of Salisbury Plain.

On first inspection, this small enclosure, encompassing just over 1.5 ha, appears to be Iron Age in date. However, a walk around the north-eastern sector of the site reveals an earlier ditch protruding out from beneath the Iron Age bank and ditch. A singular trench was placed over the junction of the two phases in the early 1960s that revealed a substantial ditch containing small amounts of bone and over 600 flint flakes. It is probable that this series of ditches and those recognisable around nearby Clifford's Hill are of Neolithic date. The Iron Age enclosure is relatively small in comparison to other sites in the area, and recently it has been suggested the site probably had a short occupational history. Unfortunately, this will be difficult to prove due to the amount of disturbance caused by decades of flint digging on the site.

Marden Henge

Marden Henge is located at NGR SU 091 584. The site is private, but two public footpaths cross the site. Park in Marden village, near the hall, at NGR SU 085 576; Marden Henge is then 350 m up the road to Beechingstoke.

Marden Henge is often seen as a poor relation to its two, better-known neighbours, Avebury and Durrington Walls. Archaeologically, nothing could be further from the truth.

Marden Henge from the south. The largest of the henge enclosures, it is in private ownership, with limited access. (NMR 24502/09 SU0958/33 taken 6 December 2006 © English Heritage)

Located in the Vale of Pewsey, Marden Henge uses the River Avon as part of the enclosure. Considering the importance of the river at Durrington Walls and Stonehenge via the Avenue, a few miles down stream, it becomes immediately apparent that this site was of major importance in the late Neolithic period.

Marden Henge is the largest henge enclosure in the United Kingdom. A ditch, with internal bank and the River Avon encloses around 14 ha. A section through the ditch in 1969 revealed a ditch over 16 m wide with a flat bottom *c.* 9 m, whilst the depth was on average 2 m. This is less than the other henge enclosures (compared with Avebury at *c.* 9 m) , but a probable result of the level of the water table in the Vale. Just inside the wide northern entrance, Geoffrey Wainwright discovered a singular timber structure in 1969, with an outer ring of twenty-one post-holes. In 1807, William Cunnington spent ten days excavating a large mound inside the henge known locally as the Hatfield Barrow. This stood an estimated 7 m tall and Cunnington records finding cremated human bones within the mound. Unfortunately, the mound was destroyed not long after. Work in 2010, directed by Jim Leary, located the ditch of the Hatfield Barrow, evidence of occupation before the mound was constructed, and a substantial post at the centre of the mound. Outside the entrance, a gravel road led to the River Avon. Unfortunately, all this is not visible to the visitor as the entire monument is plough-damaged. However, the bank and ditch are visible along a good part of its length.

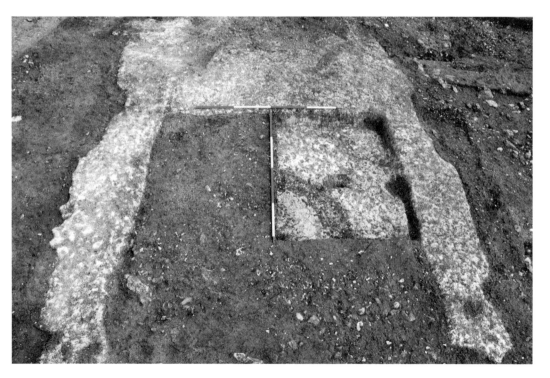

The house at Marden Henge. In 2010, Jim Leary and his team made an amazing discovery – the floor plan of a complete Neolithic house. Only 25 per cent was excavated however, and the central heath and retaining ring are clear in this photo, along with post-holes for the structure itself. (5219-8169 © English Heritage)

One feature that can be recognised is the Southern Circle, and it was here that a remarkable discovery was made in 2010. The monument, formerly thought to be a round barrow, was proved by excavation to be a henge. Moreover, on the bank of the henge was an extremely well-preserved Neolithic structure with a central hearth. A number of worked flint artefacts and bone pins were recovered inside, and nearby evidence of feasting was found mixed with Grooved Ware pottery. Quite why a structure such as this would be built on the bank of a monument is now a subject of intense debate and has implications for the way we approach further investigations on late Neolithic sites.

Wilsford Henge

Wilsford Henge is located at NGR SU 093 574. A public footpath crosses the site. If you feel the need to visit then combine this with a visit to the Marden site. Take the path out past the hall at Marden village running east; the site is 1 km along the track.

Not all archaeology in Wiltshire – or for that matter nationally – is immediately visible. That said, a number of the images contained in this book provide evidence of prehistoric and later activity, visible from the air. I have included a photograph here to illustrate the point. Recently, the Vale of Pewsey has become the focus of renewed archaeological interest. Once thought to be a later Bronze Age backwater, the area has been the site of a number of important surveys. I flew the Vale some fifteen years ago, looking for a number of sites; one – Wilsford Henge – continues to captivate me.

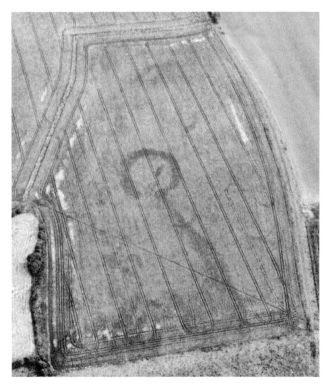

Wilsford Henge is a Class I structure – that is, a single bank surrounding an internal ditch with just one entrance – in this case facing north-north-east. The geology here comprises River Terrace Deposits, presumably left by the River Avon. The stripe running away from the ditch in the photograph demonstrates this terrace. The monument has been extensively ploughed.

Wilsford Henge from the north. Crops reveal a number of features on this site – not all archaeological. The Class I henge is easily recognisable; however, the dark stripe running from the entrance is caused by the underlying geology. (Bob Clarke)

66

When visiting the site, a slight rise to the west indicates where the bank survives as a very slight earthwork – this is the only indication that anything once stood in the field. Now, a series of photographs taken over a number of years has revealed not only the ditch but a ring of posts around the outside and a number of features within the central area.

Chisbury Camp

Chisbury Camp is located at NGR SU 278 659. For a short walk to the camp, park in the hamlet of Chisbury. The site is 100m on the road to Great Bedwyn. Alternatively, park in Great Bedwyn village centre and head north-west for 800 m, then turn left to the site. The walk is around 800m with a steady incline.

Chisbury Camp is a multivallate hillfort encompassing around 7 ha, located on an outlier of London Clay above the River Dun, which runs to the south-east. Although difficult to ascertain on the ground, it would appear the two gaps used by the road passing through the enclosure are utilising original entrances. The vallum is covered in trees, making it difficult to observe the entire circuit; however the western side of the enclosure is protected by three banks divided by two ditches. The eastern side appears to have only one bank and ditch for

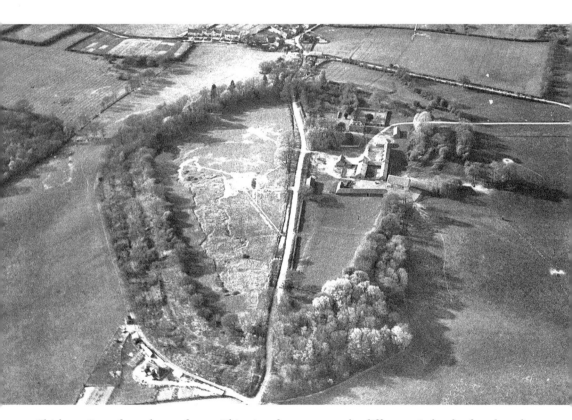

Chisbury Camp from the south-east. This view demonstrates the difference in levels of earthwork – to the left substantial multi-ditched, to the right slight and singular. (Wiltshire Heritage Museum)

most of its distance. A farm and other buildings are now on this side of the site and have masked much of the earthwork information.

To date, formal excavation of this site has been limited. A. D. Passmore recorded in his diaries (now deposited in the museum collection) that a 2-ft spear head, a number of bronze swords and a line of six urns had been found in 1900 during gravel digging. The damage caused by the extraction of a pocket of gravel, especially in the south-western sector, has been substantial. A further chance to investigate came in 1988 with some preparatory work in advance of construction. Unfortunately, the site was so disturbed that little new information was obtained.

Martinsell & Giant's Grave

Martinsell Camp is located at NGR SU 177 639, Giant's Grave is 1 km south-west at NGR SU 167 633. There are two ways to access both sites. There is a small carpark at NGR SU 184 645. Take the A345 out of Marlborough towards Pewsey, 4 km on the left to Clench and Wootton Rivers, the car park is 2 km down the road on the right. From here, you walk the escarpment for 1 km onto Martinsell Camp. Alternatively, stay on the A345 until Oare, park in the village and then ascend the steep spur to Giant's Grave, 600 m, and then carry on to Martinsell.

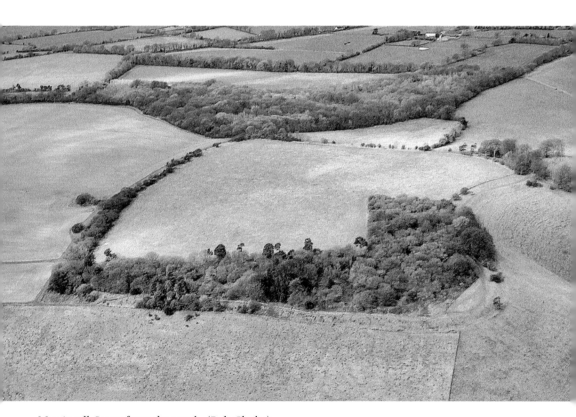

Martinsell Camp from the south. (Bob Clarke)

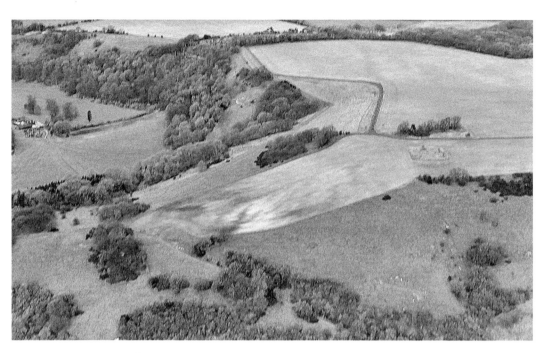

Between Martinsell and Giant's Grave, there is evidence of 'competitive feasting'. The evidence for this has been disturbed by the plough (black marks in field in lower centre of shot). (Bob Clarke)

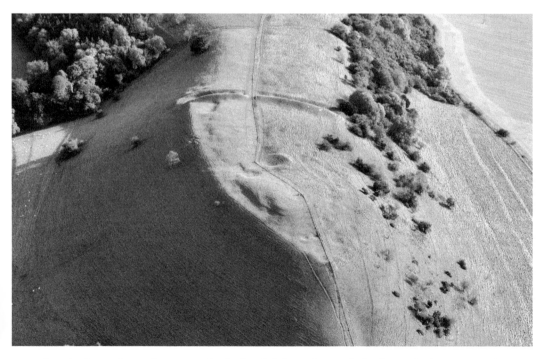

Giant's Grave from the west. The lack of defence beyond the large ditch suggests this site performed a function more involved with visibility. (Bob Clarke & Martin Kellett)

The complex comprising Martinsell Camp is located on plateau at 270 m above the Vale of Pewsey. Giant's Grave is located on a promontory that runs westward from the Martinsell enclosure. They are connected by a natural causeway that marks a geological boundary, between clay with flints to the east and the chalk spur to the west. Both have been the focus of recent archaeological work.

Martinsell Camp is a large univallate earthwork enclosing 13 ha. To the south and east, protection is afforded by the chalk escarpment that falls steeply away into the Vale of Pewsey. An entrance is located at the north-east corner of the site and is of simple construction. Recent work re-evaluating finds first discovered in the 1940s suggests that Martinsell probably dates from 600–550 BC, making the site early in hillfort terms. Further, the defensive interpretation might also be unsound. The Vale of Pewsey is home to some extremely complex late Bronze Age/early Iron Age archaeology, often in the form of large middens, made of large quantities of animal bone, pottery and charcoal. Recently, Paul Tubb has indicated these 'black-earth' sites are evidence of 'competitive feasting'. One such site stands on the natural causeway between the two earthworks.

To the west of the main enclosure is Giant's Grave. Until recently, this has been seen as a classic example of a promontory fort, but Tubb's work casts doubts on this. The site utilises the steepness of the escarpment in its otherwise poor circuitry defence, the only difference being the huge bank and ditch restricting access to the site. It is more likely that this site, with evidence of late Bronze/early Iron Age pottery and debris, was the location for feasting and display. Certainly, the site commands some stunning views and is visible from a great distance, all probably intentional.

4

Western Salisbury Plain

The extreme western edge of Salisbury Plain is the focus of intense Iron Age occupation and earthworks. There are four substantial enclosures: Bratton, Battlesbury and Scratchbury are all located on the escarpment edge, whilst Cley Hill is built around a geological outlier and covers the approaches to the Frome Gap. Recent work by Wessex Archaeology has demonstrated that major Iron Age involvement is in evidence around these sites, indicating a prolonged period of occupation, probably over the last 500 years of the first millennium BC.

Cley Hill

Cley Hill is located at NGR ST 839 449. The site is owned by the National Trust, meaning there is unrestricted access to the monument. Cley Hill is an extremely steep hill and should not be tackled without the correct footwear.

The hillfort at Cley Hill commands a 360 degree view of the landscape. It is a classic contour hillfort, the builders relying more on the topographical aspects of the geological feature it stands on than substantial earthworks. That said, the site is probably not solely a 'defensive' structure.

The landscape position ensures this site is extremely prominent, visible for some distance when approaching from the west. The slope is so steep in the north-eastern sector that earthworks appear to have been deemed unnecessary. However, this direction may not have been the intended focus of visibility. Unfortunately, a large quarry on the south-western side has caused major damage to the site, probably including the removal of an entrance in the process. However, a number of hut circles dating from the Iron Age period are visible in the northern sector of the enclosure. The site was pre-dated by at least two round barrows, prominently placed on the summit of the hill. Later, probably post-medieval, farming practice has introduced a number of lynchets onto the hill, further confusing some of the enclosure layout.

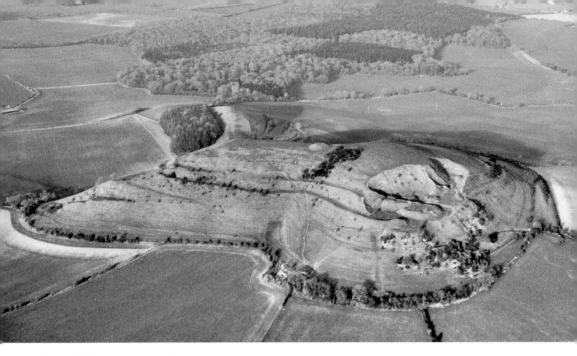

Cley Hill from the west. The prominence of the site on the landscape is clear. Note the large quarry on the south-west. (Bob Clarke & Martin Kellett)

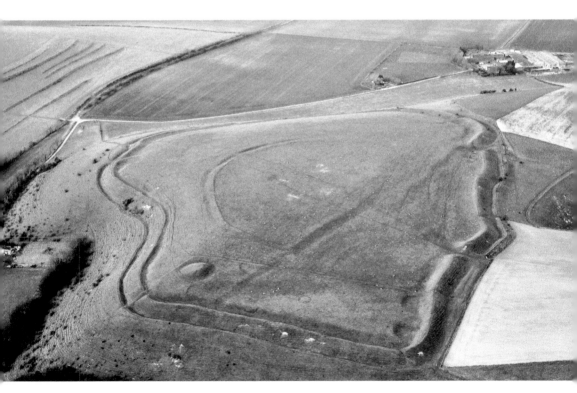

Scratchbury Camp from the south-west. The earlier enclosure and burial mounds can be seen inside the enclosure. (Bob Clarke & Martin Kellett)

Scratchbury Camp

Scratchbury is located at NGR ST 912 443. It is best to park somewhere in the village of Bishopstrow and then follow the footpath over the railway, past Middleton Farm and onto Middle Hill. Both Battlesbury and Scratchbury can be accessed from here easily. This site skirts the danger area on Salisbury Plain. Please take note that you should not pass a red flag, as this indicates live firing of weapons. You are less likely to encounter the army if you plan your visit on a weekend!

Scratchbury Camp is the largest of the hillforts in the area, enclosing a massive 17 ha. It is located on the southern edge of the Salisbury Plain massif. The River Wylye and lower valley can be clearly observed from this point, suggesting this was a focus.

The site is univallate and unusually has three entrances – all suggested to be original. The site was probably densely occupied, as the numerous remains of hut hollows can be made out in the northern and western sectors. That said, Scratchbury displays evidence of earlier periods, including round barrows and a smaller enclosure. The barrows were investigated in the early nineteenth century by Richard Colt Hoare. Primary cremations were located in three, one with an assemblage of amber. The smaller enclosure was a matter of some debate – only concluded by excavation. O.G.S. Crawford, using aerial evidence, considered the smaller 'D' shaped enclose to be a Neolithic causewayed enclosure, By 1957, this had been proven to be an Iron Age feature, as pottery from the period was located in the primary fills of the ditch.

Battlesbury Camp

Battlesbury Camp is located at NGR ST 898 456. To combine your visit to Battlesbury with Scratchbury, use the information provided for that site. Alternatively, you can park along Sack Hill, near the army camp to the north-east of Warminster, and then follow the right of way onto the hill. This route is around 400 m up onto the Plain.

Battlesbury Camp is located on a broad promontory at the extreme southern edge of Salisbury Plain. A multi-vallate earthwork encloses *c*. 10 ha, with the bank and ditch becoming more pronounced in the eastern sector. Battlesbury has been extensively ploughed in the interior, but cropmarks suggest that it is probably built over an earlier field system.

The earthworks comprise a substantial inner bank, ditch and then a further outer bank running from the probable entrance in the north-west to the southern edge of the promontory. Around the north and western parts of the enclosure, a further slight ditch transforms into a full rampart. There are two entrances to the enclosure, one in the north-west whilst at the eastern extremity a complex series of outer works protects the other. A substantial quarry ditch suggests the ramparts were strengthened at some stage. Unfortunately, Battlesbury has seen very little archaeological investigation and consequently is difficult to date accurately.

Limited excavation was undertaken by Maud Cunnington along the line of a water pipe in 1922, uncovering a number of pits containing typical Iron Age deposits. These included iron tools and pottery, along with saddle and rotary querns (suggesting a long period of use) as well as clay sling bullets – the primary weapon of defence. This was complemented recently with work by Wessex Archaeology, who discovered a dense area of occupation just

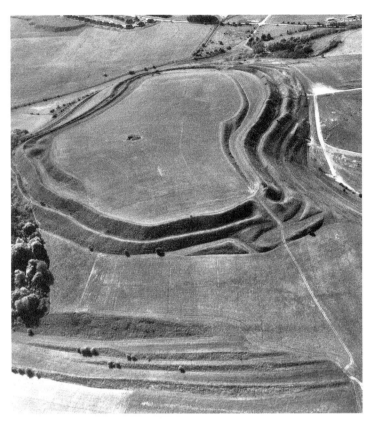

Left: Battlesbury Camp from the south-east. This picture graphically illustrates the multi-vallate nature of the enclosure. (Wiltshire Heritage Museum)

Below: Bratton Castle from the north-west. The enclosure takes up a majority of this flat promontory, capitalising on the naturally defensive aspect of the landscape. The earlier long barrow can be clearly seen. (Bob Clarke)

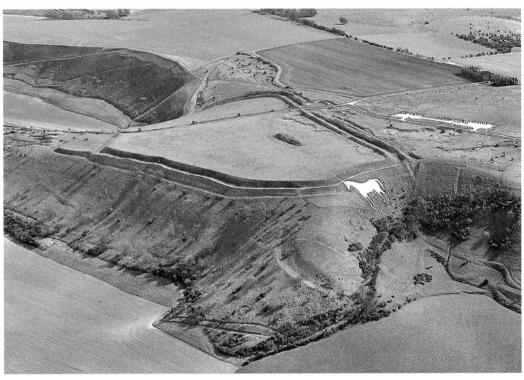

north of the hillfort. Pits and hut circles, a number of gullies and ditches along with burials and substantial artefacts demonstrated landscape use from the eighth to the fourth century BC. Although no direct correlation was noted with the nearby hillfort, parallels with other excavated sites in the county show that this arrangement is not uncommon. A large mound, located between the inner and first bank in the southern section, appears to be a motte mound of medieval date.

Bratton Castle

Bratton is located at NGR ST 900 516. This site is provided with a car park right next to the earthwork. To access follow the signs from the village of Bratton.

To visit all four sites, give yourself a full day. If you intend to use the car, it will take around four hours. Visit Cley Hill first, and then drive to the areas suggested for Scratchbury and Battlesbury. Save Bratton for last. Due to the distance between Bratton and Warminster, walking all four sites in one go is not feasible in one day. It is possible for the experienced walker to achieve the lower three in one day. Park near the army barracks mentioned for Battlesbury. Walk across the edge of the Plain to Scratchbury, then down onto the road and head west through Warminster to Bugley. From there, take the footpath to Cley Hill, back to Bugley and then on to the car. This route is 17 km.

Bratton Castle is located on the northern edge of the Salisbury Plain escarpment on a broad promontory. It is double bank and ditched on the accessible southern and eastern side, but has slighter earthworks overlooking the steep fall of the chalk plateau. The hillfort provides a fantastic view across the Vale of Malmesbury and the towns of Trowbridge and Melksham.

The site is only 5 km north of Battlesbury and undoubtedly has a connection with that, Scratchbury and Cley Hill. There is an outer rectangular enclosure at the proposed north-eastern entrance; however the earthworks are surprisingly slight. This is more likely to be some form of stock enclosure and might even be early Romano–British in date. That said, a further entrance bisecting the southern vallum also has a rectangular enclosure in front of it. This is smaller and has substantial bank and ditch protection pointing to an Iron Age date. Excavation on the site has been limited to some intrusive trenching by a local antiquarian in the late nineteenth century, which located quern stones and a substantial amount of pebbles – slingshot ammunition. The site has been damaged inside and out by quarrying activities, especially in the southern sectors and around the entrance.

Inside the site, there is a large long barrow. This Neolithic monument is 74-m long and still stands to a height of 4 m. Unlike the hillfort, it has attracted the attention of a number of excavations, conducted independently by William Cunnington and John Thurnam. Interestingly, Cunnington unintentionally demonstrated that the surrounding hillfort was occupied, when he came across 1.5 m of black earth, pottery and animal bones filling the earlier ditches. Thurnam, when digging at the eastern end of the barrow, located evidence of partially cremated human remains – typical of many earthen long barrows in the County.

5

The Stonehenge Landscape

Located on the southern edge of Salisbury Plain, the Stonehenge landscape is impressive. At the heart is the world-famous Stone circle, while around it lie some of the most important Neolithic sites in the country. Interlaced with those are extensive barrow cemeteries from the early Bronze Age. A visit to Stonehenge is a very commercial experience; however, just a few hundred meters in any direction and you can find yourself totally alone. This landscape has taken over 2,000 years to evolve, and has attracted many excavations over the years. Many of the artefacts can be found in the Salisbury and South Wiltshire Museum and the Wiltshire Heritage Museum.

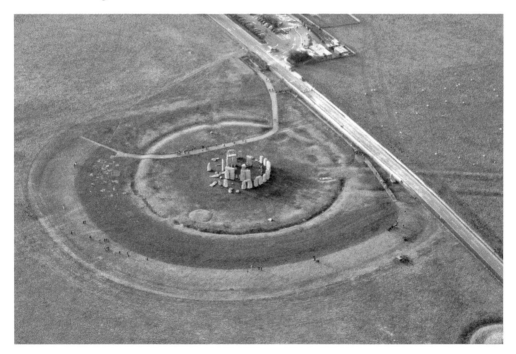

Stonehenge from the south-east. (Bob Clarke & Martin Kellett)

Stonehenge

To give more than a brief overview of Stonehenge and its immediate landscape would require a majority of the pages of this guide. The landscape is well-provisioned for the visitor and you should plan a whole day for your visit here. To fully appreciate the enormity of the site, you should consider the following route – resist the temptation to visit the henge first! Just one point: check your OS map and note where the purple outline is. You are allowed anywhere within that area as it is National Trust land. From the Mesolithic postholes in the Stonehenge car park, head west past a group of prominent barrows, towards the big gap in the trees, then down to the western end of the Cursus. From the bank and ditch at this end, turn and head east along the full length of the Cursus, over the style in the left-hand corner, and onto the track. Turn right and you will be able to see the ditch of the long barrow in the copse as you walk the first few metres. The path takes you on to the Old King Barrows, then the gap where the Avenue cuts through, before you encounter the impressive New King Barrows. Descend the Down back to the visitors centre, then visit Stonehenge.

Stonehenge, the internationally famous stone circle, stands on the southern edge of Salisbury Plain and at the centre of a highly monumentalised prehistoric landscape. The monument, as presented today, is the product of a number of major construction phases spanning at least 1,400 years. The site attracts nearly one million visitors a year, most of who concentrate just on the monument itself.

Words relating to Stonehenge run into the millions. What appears here is a brief account of the known phases of construction, along with an account of some of the groundbreaking work of the Stonehenge Riverside Project. It is important to remember from the outset that it is highly probable that the phases before the introduction of stone onto the site were punctuated by long periods of abandonment.

The earliest monumental evidence in this immediate landscape was not the henge itself but a number of postholes, the earliest dating to 7180 ± 180 BC, a few hundred metres to the north-west of Stonehenge. The positions of these can be found at the lower end of the car park (near the current toilet block) marked by large white discs on the tarmac. What influence these had, if any, on the later Neolithic settlements in the area is unclear. It is known, however, that the posts were pine, indicating a different climate to today.

Around 2950 BC, a circular monument – the first recognisable phase of Stonehenge – was constructed with a bank and ditch, the ditch

Right: The earliest recognised site in the immediate area is that of the Mesolithic postholes, found during the extension of the car park. Their positions are marked by large, round discs painted on the tarmac. (Bob Clarke)

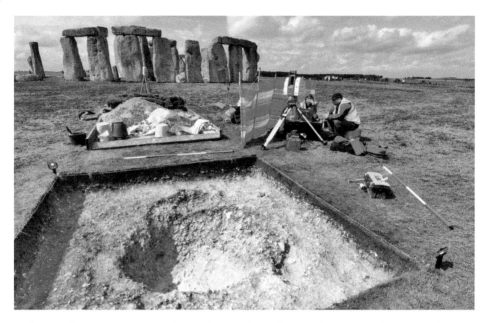

Aubrey Hole – Laser scanning the surface of the Aubrey Hole, excavated with the find of numerous re-deposited cremations in 2008. (Bill Bevan)

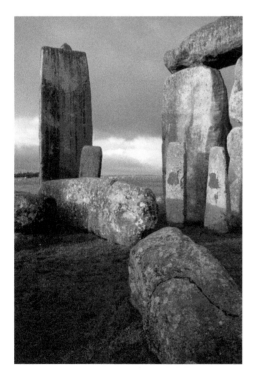

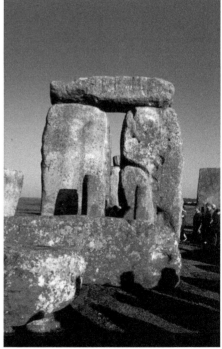

Above left: The chaotic scene inside the monument today. The smaller stones are the Blue Stones from south-west Wales. (Wessex Archaeology)

Above right: Trilithon. One of five such features within the stone circle. (Bob Clarke)

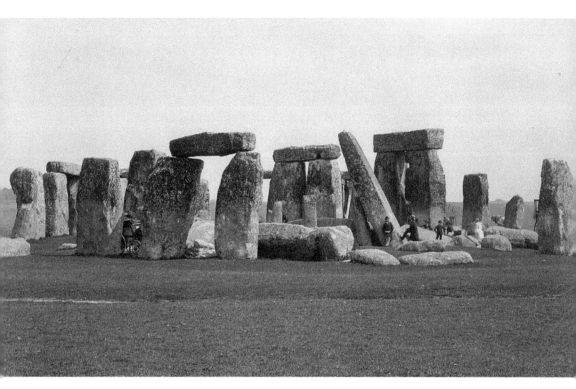

Above and below: Past and Present. Compare the two photographs, one of the site in Victorian times, the other in the early twenty-first century. Do you notice the differences? (B/W Photo – Wiltshire Heritage Museum; Colour – Wessex Archaeology)

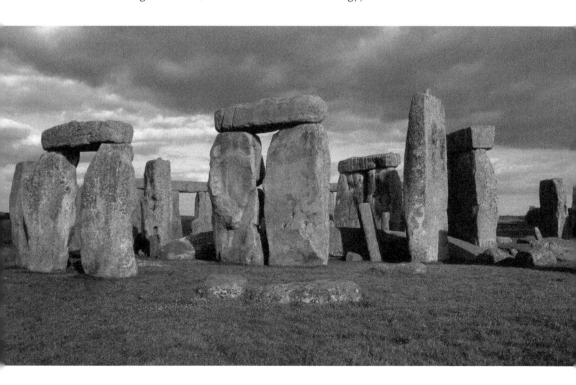

being on the outside ditch on the outside. There were a possible three entrances to the centre at this time. Deposits of animal bone and a number of exotic artefacts were placed in the terminals of the ditches. Just behind the bank, fifty-six pits, originally containing posts, were dug. These were first discovered by John Aubrey in the seventeenth century – hence the name 'Aubrey Holes'. In this period, the monument was used for funerary activities as human remains have been located. Indeed, recent radiocarbon dates from the Stonehenge Riverside Project suggest the monument was used for burials over a 500 year period. This is important, as it suggests all phases of construction appear to have been connected with funerary practices. Many of the Aubrey Holes also had cremations and artefacts placed in them, the earliest recently dated to 3030–2888 BC. By 2550 BC, a series of timber settings and stake holes appeared in the area enclosed by the bank, possibly to guide people around the interior. Much of the evidence for this has been lost, due to the work surrounding the erecting of the later stones, but there is just enough to infer the earlier settings. From c. 2500 BC, the first of the monumental stone constructions had appeared on the site.

The phases of lithic construction on the site are complicated and will, no doubt, be revised over time. It appears that bluestone was imported from the Preseli Hills, located in West Wales, c. 2500 BC, and arranged in a double circular row; the west to north quadrant of this has not been investigated, so whether it was a complete circle or not is unclear. At this time, the four station stones and Heel Stone – an undressed sarsen – were also erected. Further work included the reorganisation of the main entrance and the addition of the Avenue to a length of 530 m. The original bluestone setting did not last long, as it was removed and the stone holes backfilled. The monument then underwent a major change. Massive sarsen stones were erected in a circle, with lintels presumably completing a circumference. Inside this arrangement, five sets of trilithons were constructed. The sarsens are a local stone, traditionally thought to originate from the Avebury region. There are moves to substantiate this claim with an archaeological assessment. As you walk around the site, notice that the height of the trilithons falls to the north whilst the remnants of the outer circle suggest the lintel top of this was horizontal.

The Avenue

In two further episodes of re-work, the bluestones were reintroduced onto site first as an oval-shaped arrangement between the trilithons and outer circle, then as a horseshoe with the open end towards the entrance. Later, the Avenue was extended down as far as the River Avon. The Avenue comprises twin parallel ditches, with a bank on the outside, and is visible for the first 530 m as it runs away from the henge. It then makes a sharp turn to the east and heads up and through the gap between the New and Old King Barrows. From there, it makes a broad curve to the south until it meets the river. This extension was originally considered to be a later – possibly mid-Bronze Age – addition. However, a major new discovery in 2009 has cast doubt on that.

Bluestonehenge

Recently, the Stonehenge Riverside Project has challenged the whole debate surrounding the dating, sequence and even use of Stonehenge. A number of important discoveries have been made in the last few years, not least the discovery of a further standing stone monument at the river end of the Avenue. Immediately dubbed 'Bluestonehenge', the feature was recognised after

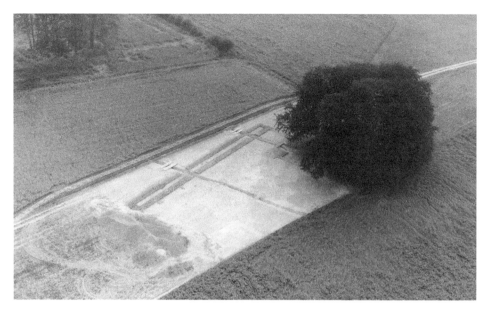

Investigating the Avenue during the construction of the A303. The two parallel Avenue ditches run diagonally, top left to bottom right. One is partially obscured by the trees. (Boscombe Down Conservation Group)

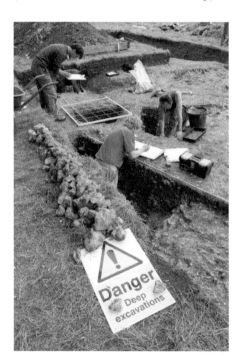

Above Left: 'Bluestonehenge' under excavation. The henge is located at the end of the Avenue that meets the River Avon. (Bill Bevan)

Above Right: The discovery of an antler pick in the bottom of one of the stone holes of 'Bluestonehenge'. (Bill Bevan)

geophysical work in the areas surrounding the terminus of the Avenue. The feature was partially excavated in 2009 and this, coupled with the geophysics, suggests the monument originally contained at least 25 standing stones. The importance of this drives the recent theory that the River Avon was an intrinsic part of the Stonehenge landscape and featured heavily in major funerary rites. Durrington Walls and Stonehenge are linked by the river; a monument at that junction cements the connection.

Other monuments have also been investigated in the area. Work on the Cursus, to the north of Stonehenge, has demonstrated that this slight earthwork was constructed somewhere between 3630 and 3375 BC. The Cursus is probably the most enigmatic of sites in the area. The name, implying some sort of racing track, was first coined by William Stukeley in the early eighteenth century. Since then, it has defied interpretation. The monument is 2.7 km in length and 150 m at the widest point, comprising a ditch less than 1 m deep but up to 2 m wide. This makes it extremely vulnerable to agricultural damage and the monument is now extensively damaged in places along its length. Excavations by Christie in 1959 at the western end revealed a large 2 m deep ditch with an internal bank, whilst at the western end work by Julian Richards in 1982 proved that the monument was aligned on an earlier long barrow.

Durrington Walls

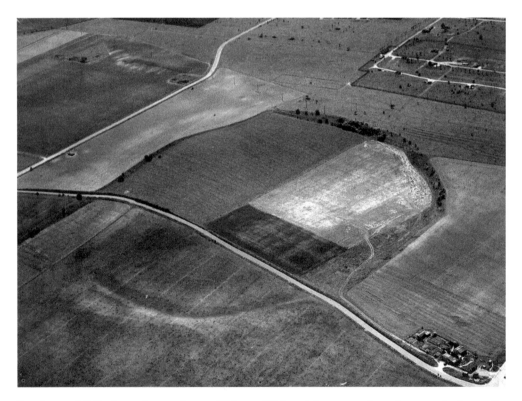

Durrington Walls from the north-east. This pre-Wainwright excavation photograph shows the extent of the enclosure under destructive agriculture. (Wiltshire Heritage Museum)

Above left: Durrington Walls bank and ditch. The ditch is slightly visible on the ground; however the bank outside it survives to just over 1m in the eastern sector. (Bob Clarke)

Above right: Durrington Walls Trench 1, a substantial area of pits was discovered during work around the entrance. (Bob Clarke)

Durrington Walls Trench 1. A large area of occupational debris was located in Trench 1, along with the hearths of at least five Neolithic houses. (Bob Clarke)

Durrington Walls is located at NGR SU 150 137 and can be easily accessed via the old Durrington–Amesbury Road. The site is signposted and there is a small carpark opposite the site. You can also access Woodhenge from here.

Durrington Walls Henge Enclosure sits at the eastern extremity of a highly monumentalised landscape. A landscape itself focussed on the River Avon. The enclosure has been excavated twice in recent years, and the second campaign has re-written much of the story of the later Neolithic.

Durrington Walls is a roughly circular enclosure, with a deep internal ditch and large bank outside that. The bank uses the topography of the large, dry, gully it encompasses, but stands as a more traditional arrangement as the enclosure reaches the River Avon. Excavations in 1966/67, in advance of a new road layout, investigated both these features and one ditch terminal near the river. The work, directed by Geoffrey Wainwright, also had the opportunity to study a 400 m strip through the enclosure itself. The ditch was over 5.5 m deep and 17 m wide at the top. The base of the bank was over 30 m wide, making this a massive undertaking. Along the route of the road, two posthole circles were located. The Southern Circle, located close to the entrance near the river, was a two phase structure, similar in size to nearby Woodhenge. The Northern Circle was a slighter affair, approached via an avenue flanked by posts. Neither feature was fully excavated. Wainwright's team discovered copious amounts of Grooved ware pottery in primary contexts across the site. (You will remember this type appears on other sites of similar age). Radiocarbon returned dates of 2200–1900 BC for the construction of the enclosure, with evidence of an earlier settlement from the pre-bank ground surface suggesting 2600 BC.

The Stonehenge Riverside Project undertook two seasons of excavation (2005–06), including work on the unexcavated section of the Southern Circle and the area closest to the

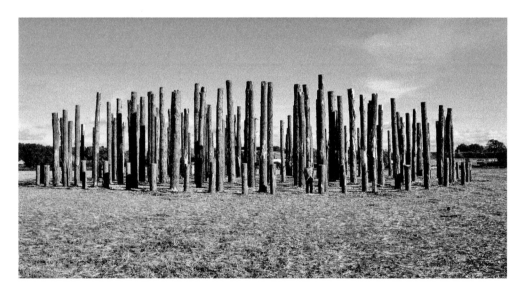

The Southern Circle Reborn. Both the Wainwright and Parker-Pearson excavations investigated a feature known as the Southern Circle. A full-size structure, possibly demonstrating what the site looked like in the third millennium BC, was later constructed for the television programme Time Team. (Bob Clarke)

Avon. The Southern Circle was found to be oval in shape. Many postholes had been re-cut, suggesting a timber monument constantly changing (not unlike Mike Pitts' thoughts on the Sanctuary near Avebury). Dating evidence provided a determination of 2570–2350 BC for this activity. The whole Southern Circle was later recreated for the Time Team television programme. Large areas of occupation were in evidence across the site, and a number of shelters or huts in the centre of the enclosure were investigated. Each had a hearth at the centre. The riverside entrance had been extensively occupied – as the amount of debris, black earth and hearths attest to – and was linked to the River Avon by a gravel roadway, in a similar way to that discovered recently further up stream at Marden Henge. Clearly the river must play an important part in communication between the sites, just as Stonehenge is also linked to the River Avon by the Avenue. The link between Durrington Walls and Stonehenge may be for the dead – a route for carrying the spirit or soul to a place of burial, rather than the physical remains. Early results suggest Durrington Walls is contemporary with Stonehenge, indicating that the link via the River Avon is of great importance.

Woodhenge

Woodhenge is located at NGR SU 150 434 and can be easily accessed via the old Durrington–Amesbury Road. The site is signposted and there is a small car park opposite the site. You can also access Durrington Walls Henge Enclosure from here.

Woodhenge was one of the first major discoveries made by aerial archaeologists. From the early nineteenth century, the earthwork was thought to be a badly damaged barrow. It even had a name, 'The Dough Cover'. Then, in 1925, Sqn Ldr Insall photographed the site from the air. The image showed a number of concentric circles marked out by pits, along with a substantial ditch on the inside of the bank. Since then, the monument has been the focus of a number of excavations.

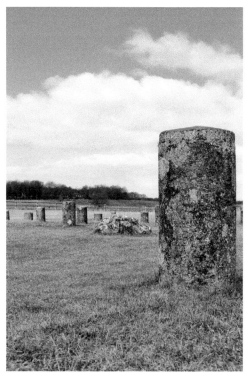

Through two seasons (1926–27) the Cunningtons totally excavated the central area; they are responsible for the name 'Woodhenge', making reference to the closeness of the monument to Stonehenge. What they discovered was a series of six, roughly circular rings of post holes, surrounded by a ditch and an external bank. The rings were accessed by a singular causeway through the bank and ditch at the north-east point. The rings appear to have a clear way through to the centre of

Right: Woodhenge inner circle and flint cairn. (Bob Clarke)

85

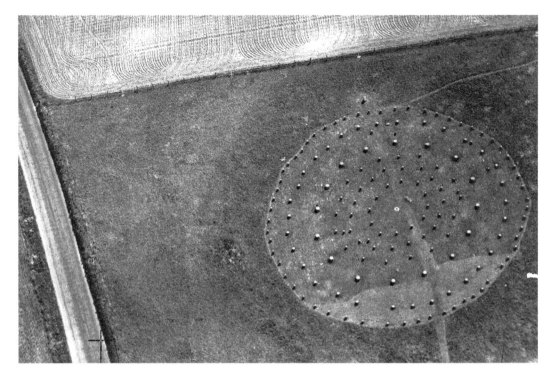

Above: Woodhenge, from the air, showing the concentric circles laid out after the Cunningtons' excavation. (Wiltshire Heritage Museum)

Below: The layout of Woodhenge as seen by the visitor. (Bob Clarke)

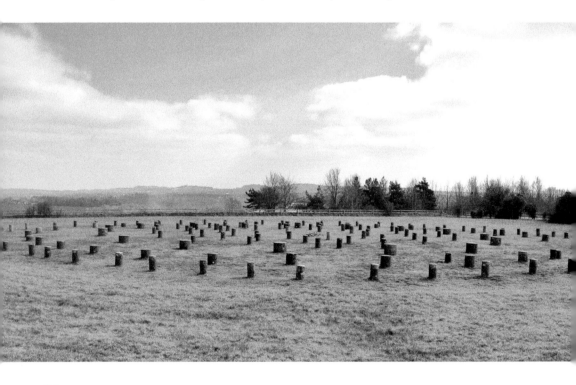

the monument at this point too. The ditch was irregular in width with a flat bottom, the bank a plough-damaged feature surviving as a slight earthwork. The Cunningtons also located a burial of a child 'about three years of age, whose skull had been cleft before burial, thus suggesting that the burial was in the nature of a dedicatory or sacrificial one'. Whilst the interpretation may be questionable, the location is not, and is marked by a flint and concrete cairn near the centre of the site.

In 1970, as part of the ongoing investigations into henge enclosures, Geoffrey Wainwright placed a trench across the bank and ditch. The ditch at its deepest was 2.2 m and ten antler picks were found on the bottom. A radiocarbon determination from one of them suggests its digging *c.* 2480–2030 BC. A selection of Grooved Ware sherds was also present in the primary silts, along with two arrowheads. An environmental sample suggests the henge was constructed in an area of dry grassland. Work in 2006 by the Stonehenge Riverside Project noted that the timber circles had probably been replaced by a number of sarsen features. Josh Pollard noted three new stone sockets in the singular trench reminiscent of a cove.

King Barrow Ridge

King Barrow Ridge can be accessed from either the A303 or Larkhill. Larkhill is probably the safest route, having the opportunity to park in the lower part of the old Larkhill married quarters on Strangeways (NGR SU 137 435). From here, the terrain is flat and takes you past the eastern end of the Cursus, then on to the Old then New King Barrows. The total round trip is 3 km.

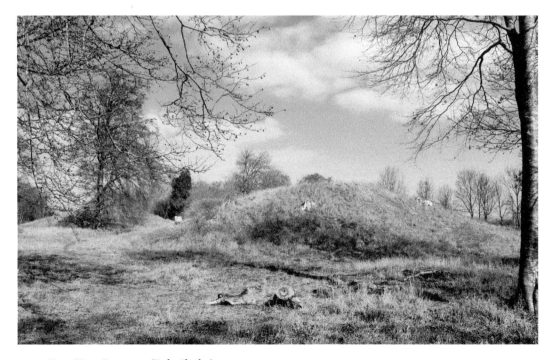

New King Barrows. (Bob Clarke)

King Barrow Ridge is a low plateau that rises between Stonehenge and Durrington Walls. Running north to south along the plateau is a linear cemetery, comprising twelve large mounds, whilst cropmarks and geophysics demonstrate that there was probably double that number originally. The site provides some spectacular views across the Stonehenge landscape to the west of the cemetery.

The burial mounds are today divided into the New and Old King Barrows, following a convention first described by William Stukeley in the early eighteenth century. The division makes reference to the differences between the north and south barrows. The seven in the southern region appear much more regular in appearance and alignment. Today, there is a gap through the centre of the cemetery through which the Stonehenge Avenue runs. Unfortunately, this has been reduced to cropmarks by agricultural exploitation. Richard Colt Hoare noted in the early nineteenth century that all had been investigated but very little of what was discovered was known. However, records surviving from the opening of two barrows within the linear cemetery in 1649 noted that one yielded antler and horn, probably from the construction of the monument, whilst another produced a 'bugle-horn tipped with silver at both ends', probably a much later, historic period deposit.

The opportunity to learn more about the New King Barrows came in 1990, when severe storms uprooted over 100 mature trees. As the trees were blown over, their roots exposed substantial amounts of archaeology. Wessex Archaeology spent four weeks recording the exposed evidence. The results demonstrated that the pre-barrow ridge was, as was previously thought through fieldwork by Julian Richards in the early 1980s, the focus of considerable activity throughout the Neolithic period. The analysis of snails in the buried soil noted a change to a grazed open site prior to the construction of the barrows. The barrows themselves were built with a core of turf and soil capped in all but one case by chalk.

Bush Barrow and Normanton Down Cemetery

Bush Barrow is located at NGR SU 1164 4126. The most convenient and safe parking is at Stonehenge. Bush Barrow is also a convenient point from which to explore the rest of the Normanton Down barrow group. If you intend to visit the Lake Down barrow group, turn left onto the byway when you reach the eastern extremity of the Normanton Down cemetery.

The Normanton Down barrow group contains a number of rare monument types. However, the discoveries made during the excavation of Bush Barrow, otherwise known as Wilsford G5, remain without parallel. Currently, the barrow has a circumference of *c.* 40 m and stands to just over 4 m. Recent LiDAR (optical mapping) has revealed that the barrow is on the highest point of the Downs. The mound is badly scarred from years of investigation; indeed, Sir Richard Colt-Hoare noted after his excavation of the site that 'the first attempts made by Mr Cunnington on this barrow proved unsuccessful, as also those of some farmers'. This all changed when, in 1808, Bush Barrow was successfully excavated. Cunnington discovered 'the skeleton of a stout and tall man lying from south to north' accompanied by a range of metal objects. On his breast was a sheet gold lozenge, finely decorated and mounted on a thin piece of wood.

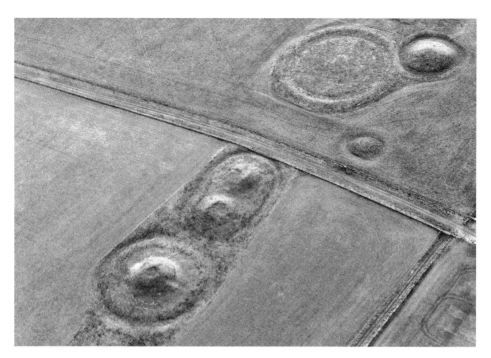

Bell barrows on Normanton Down. The two in the centre are surrounded by a singular ditch, clearly indicating a blood or political association. (Bob Clarke & Martin Kellett)

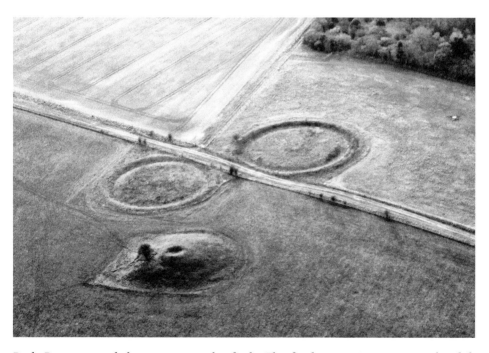

Bush Barrow revealed some spectacular finds. The final excavation campaign has left a depression in the top of the barrow. Just to the north is a pair of fine disc barrows. (Bob Clarke & Martin Kellett)

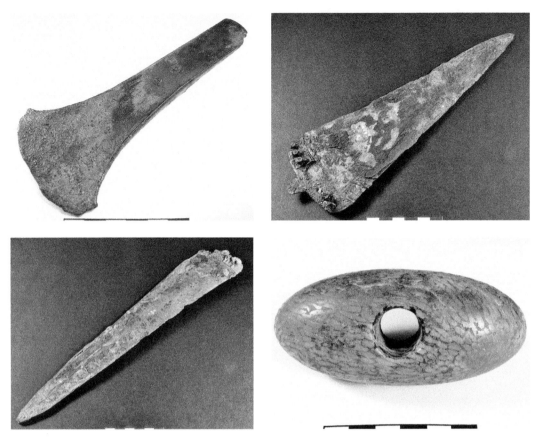

Clockwise from top left: The bronze, flanged axehead, with traces of coarse cloth visible on the blade, found near the shoulders of the primary male inhumation in Wilsford G5. (Wiltshire Heritage Museum)

A copper dagger (Amorico British Class 1a), with a small tang, six rivets and parts of a wooden sheath adhering to the blade. Originally, the handle was inset with thousands of gold pins. It was found near the right arm of the Wilsford G5 inhumation. (Wiltshire Heritage Museum)

The bronze dagger (the largest found in Wiltshire) with six rivet holes (three remaining) and parts of a wooden sheath adhering to the blade, decorated with a rounded ridge, found, near the right arm, with the Wilsford G5 inhumation. (Wiltshire Heritage Museum)

The polished oval mace-head, containing the fossil *stromatoporoid*, perforated through the centre, the drilling containing traces of bronze. This was found by the right side of the inhumation in Wilsford G5. It was possibly part of a type of sceptre. (Wiltshire Heritage Museum)

Opposite top left: The large, gold, lozenge-shaped breast plate found with the primary male inhumation (over the chest) in Wilsford G5. It is 185.5 mm long and 157 mm wide. The lozenge is manufactured from thin sheet gold, between 0.1 and 0.2 mm thick, which covered a wooden plaque. The decoration includes four nested, lozenge-shaped bands of four engraved lines each. The central one contains a chequered motif, with a zigzag design between the outer two bands; the plate is perforated at both ends. (Wiltshire Heritage Museum)

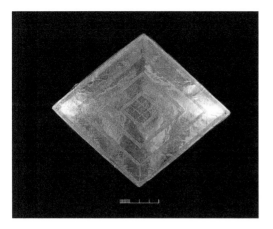

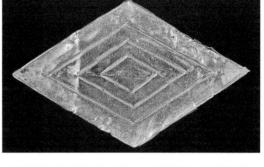

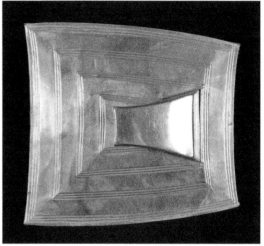

Top right: The miniature gold lozenge-shaped ornament, decorated with three nested lozenge-shaped lines (engraved). It is 31.7 mm by 19.5 mm. This plate was found by the right side of the inhumation in Wilsford G5. (Wiltshire Heritage Museum)

Right: The gold belt hook, decorated with four nested rectangular bands of three engraved lines, found near the right arm of the inhumation in Wilsford G5. (Wiltshire Heritage Museum)

Another, smaller lozenge and a gold sheet belt buckle were also present. Three bronze daggers, one with a finely decorated hilt executed by gold pins, a bronze axe and the remains of a possible shield or helmet were all with the burial. As was a polished mace head, fashioned from a piece of fossiliferous stone, drilled and presumably adorning a decorated shaft. If this interpretation is correct, a number of zigzag-cut antler rings appear to have provided the decoration. The finds, some of which are illustrated here, form the centrepiece of the Bronze Age collection housed at the Wiltshire Heritage Museum in Devizes.

Bush Barrow is but one of over twenty substantial Wessex-type barrows that comprise the linear cemetery on Normanton Down. All were the focus of excavation between the early eighteenth and late nineteenth century. The cemetery runs east to west along a prominent ridge, in clear view of Stonehenge. Substantial disc barrows at the western end of the cemetery flank the byway from the north, and from here the barrows run for just over a kilometre. Mixed in with bowl barrows are a number of well-preserved bell barrows, including a pair surrounded by a singular ditch (NGR SU 120 412). Both were investigated in the early eighteenth century.

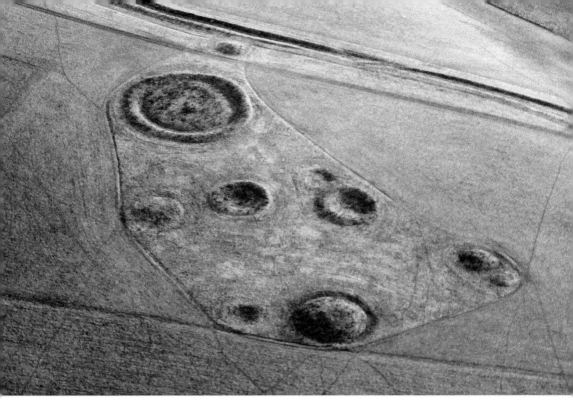

Lake Down Barrows from the north. The number of pond barrows on this site makes the group an extremely important collection. Note the mid-Bronze age ditch running across the back of the group. (Bob Clarke & Martin Kellett)

Lake Down Barrows

Lake Down Barrows is located at NGR SU 117 393. The best way to view this cemetery is to park at Stonehenge and then take the byway south from the end of the car park. On reaching the Normanton Down group, turn east and walk to the next bridleway, then continue south for a further two kilometres. Lake Down cemetery and associated earthworks are to your west.

Lake Down barrow cemetery is an outlying, nucleated group 3 km due south of Stonehenge. All the barrows have been excavated, but unfortunately few records of the proceedings were maintained.

Lake Down barrow cemetery is located on the end of a low, north-pointing spur. This whole area is enclosed by a substantial series of boundary earthworks, probably of Bronze Age origin. To the west of the group there are traces of a prehistoric field system. What makes this barrow cemetery interesting is the distribution of 'Wessex' types (*see Winterbourne Stoke section*) contained in the group. There are five bowl barrows, two clearly connected, a substantial disc barrow and most importantly four pond barrows. Pond barrows are, by their very nature, depressions with a surrounding bank. Along with disc barrows, they are the most susceptible to agricultural practice. Indeed, many were filled in under the auspices of being an obstacle to increasingly mechanised agricultural practice from the 1940s. The disc and bowl barrows were investigated in the early nineteenth century by the Revd Edward Duke, but little remains of his

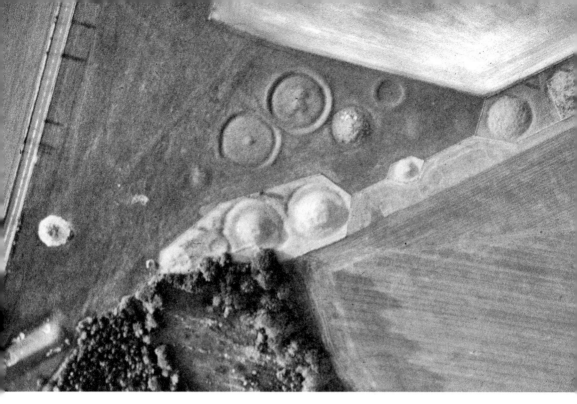

Winterbourne Stoke Cemetery. The interaction between the bell and disc barrows is clear to see, as is the small pond barrow overlying the bell barrow ditch (*centre of photo*). The white barrow on the left is the result of rabbit damage. (Bob Clarke)

discoveries save the contents of the tump at the centre of the monument. The disc barrow contained a cremation in a very small urn (probably recognisable today as a 'grape cup' often associated with cremations). Other cremations have come from the site, but no indication as to any accompanying cultural material has thus far been located.

Winterbourne Stoke Barrow Cemetery

Winterbourne Stoke Cemetery is located at NGR SU 102 414. The site can be accessed on foot through a small copse owned by the National Trust. There is a lay-by on the east-bound side of the A303 next to this. The road is dangerous here, so please take care.

Winterbourne Stoke Barrow Cemetery is one of the finest and most descriptive early Bronze Age burial grounds in the country. The cemetery is aligned on the longitudinal axis of a much earlier Neolithic earthen long barrow. Practically every example of classic 'Wessex Type' burial mounds survives, including Bowl, Bell, Saucer, Disc and Pond; along with many of the subtle variations often recognised. The close proximity of the barrows to each other allows the visitor the opportunity to explore a number of key archaeological principles. By studying the way one feature respects or overlies another, it is possible to 'phase' some of the construction on the site.

It is also conceivable that some level of social, political or religious importance can be recognised in the central area of the cemetery. Two large bell barrows dominate the linear series, running north to east from the Long Barrow, the ditches interconnecting. Directly opposite and 50 m to the north, two disc barrows also display a level of interaction, and it is tempting to suggest that both are related in some way. The majority of the barrows here have been investigated, primarily in the early nineteenth century and a great number of the finds now reside in the collection at the Wiltshire Heritage Museum in Devizes. The artefacts recovered demonstrate that the often singular, primary occupants of the barrows had probable political and hierarchically influential positions with contacts spread across Europe.

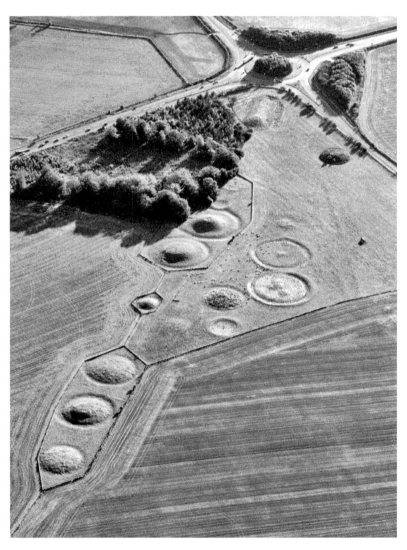

A fine photograph from the north-east, demonstrating the importance of alignment on the cemetery. The Bronze Age aspect also includes the much earlier, earthen Long Barrow. (NMR 15077/13, 18 October 1993 © Crown copyright. NMR)

The Monarch of the Plain. (Bob Clarke)

Monarch of the Plain

The Monarch is located at NGR SU 1108 4276. The site can be accessed directly from the A345 or be incorporated as part of a longer tour of the Cursus Barrow group and Cursus.

The Monarch of the Plain is a substantial Bell Barrow located a few hundred metres south of the western end of the Stonehenge Cursus. It is placed at the western extreme of the 1.2 km barrow cemetery known as the Cursus Barrow group. The earthwork is 54 m in diameter and nearly 3 m high, making it one of the largest surviving burial mounds in the county. The Monarch was investigated by Richard Colt-Hoare in the early nineteenth century, who located 'charred wood' but no burial or cremation. This impressive monument gives some indication as to the importance of individuals buried in such barrows.

6

The Vale of Wardour

The Vale of Wardour, along the south-western edge of Salisbury Plain, appears to have been the focus of Iron Age activity. A number of enclosures from the mid–late first millennium BC overlook the river valleys. It is also home to one of the most impressive multi-phase landscapes outside of Avebury and Stonehenge – Whitesheet Hill.

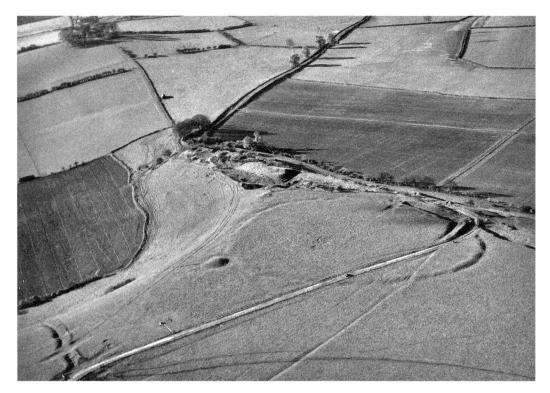

Whitesheet Hill Causewayed Enclosure from the south. The site has been proven to date to the Neolithic, through two excavations. Note the prominent barrow that overlies the ditch. (Wiltshire Heritage Museum)

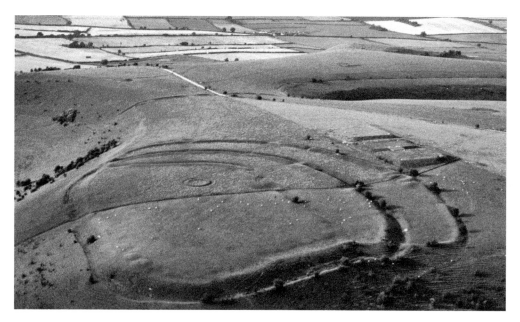

Whitesheet Hill Castle from the south. This promontory fort demonstrates the constant re-modelling that occurred on some mid-Iron Age sites. (Bob Clarke)

Whitesheet Hill

Whitesheet Hill is located at NGR ST 802 352. To find the car park, leave the A303 at Mere and take the B3092 to Stourton. 1.5 km past the village and house you will come to a crossroads. Turn right, and 1 km on is a car park. The archaeology is a further 500 m walk up the hill.

Whitesheet Hill is a plateau comprising mostly middle chalk above 200 m Ordnance Datum. The views across the Blackmoor Vale and to the north-east higher chalk of west Wiltshire are stunning. The hill contains a number of important, largely uninvestigated, prehistoric monuments ranging from the Neolithic to the Iron Age, and because of this the Whitesheet Hill landscape is described here as one site.

The causewayed enclosure situated on the north-eastern spur of Whitesheet Hill is an easily accessible and descriptive site. An interrupted ditch-work of at least twenty-three segments encloses an area of just under 2.5 ha in an oval shape. Basic investigation of the earthwork demonstrates that the causewayed enclosure pre-dates the period of circular barrow construction, as a large bowl barrow overlies part of the ditch in the southern part of the circuit. The monument proved to be Neolithic in origin when Stuart Piggott and J. F. S. Stone placed two trenches across the enclosure in 1951. Then small sherds, similar to those found in the lower ditch fill at Windmill Hill – another causewayed enclosure near Avebury – were located along with enough flint tools to support the Neolithic interpretation. In 1990, a further opportunity to investigate the site arose when a new water main was laid across the site. Wessex Archaeology encountered a number of features, but by far the most significant was a section across the ditch. This was almost 3 m deep and material throughout the fill provided a number of radiocarbon determination. The samples suggest the ditch was constructed between *c.* 3710–3380 BC, a corresponding date to those obtained from of the similar sites.

To the north-east of the causewayed enclosure, there is a very slight but large oval enclosure, encompassing 3 ha. It has yet to be dated, but a detailed earthwork survey by the Royal Commission on the Historical Monuments of England discovered evidence of a similar interrupted ditch system to that found at the causewayed enclosure. Two large cross-ridge earthworks segregate areas of the spur. The first, a linear ditch that lies between the causewayed ditch and the hillfort, was investigated in 1990, with the results suggesting a Bronze Age date. A further linear ditch is located 500 m to the east of the hillfort. Dating this has proved problematic, as evidence from a pipe trench suggests a Roman date might be in order. A number of round barrows dot the hill, including a small cemetery running west from the large bowl barrow overlying the ditch of the causewayed enclosure. There is also evidence of early Bronze Age funerary practice on the southern extremity of the hillfort. That said, beware the well-preserved 'disc barrow' within the fort. It is, in fact, an eighteenth-century garden feature, probably intended to protect saplings from the attention of animals.

To the south of the causewayed enclosure is an impressive triangular promontory fort, enclosing just over 5.5 ha. The southern-facing edge of the fort is protected by a single rampart and ditch and the approach from the north is defended by a series of earthworks constructed in phases. Current thinking suggests the middle bank was complemented by an outer work, and then some time later a further bank and ditch was built inside the initial one. It is probable that features discovered through the RCHME survey, that lie immediately to the northern corner of the outer rampart, are the remains of a further interrupted ditch enclosure, possibly dating to the Neolithic.

Figsbury Rings

Figsbury Rings is located at NGR SU 188 338. There is a car park close to the site. Take the A30 from Old Sarum heading to Stockbridge, at Heatherlea Farm turn right and park 300 m up the track.

Figsbury Rings, at Winterbourne, to the north-east of Salisbury, is a circular Iron Age fort located on land owned by the National Trust. The site stands at around 147 m Ordnance Datum, at the western end of a small spur overlooking the River Bourne.

Figsbury Rings has proved a difficult site to interpret. The outer works, enclosing 6 ha, were investigated in 1924 by Maud Cunnington. She demonstrated that the outer ditch conformed to the typical Iron Age morphology – that is, an external ditch, originally 4 m deep and 10.5 m wide at the top, cut in a V section. Immediately behind this was a bank 3.5 m high. To the south-west and north-east, there are causeways through the bank and across the ditch, which appear to be original entrances. What has caused much debate is a second ditch, built 30 m inside the outer bank. Strangely, it has no bank, and more problematically does not interact with other features on the site, making it impossible to phase through earthwork survey alone. Indeed, William Stukeley noted that the inner ditch had no corresponding bank in 1725, suggesting this had always been the case. Cunnington proposed in 1924, after excavation, that the inner ditch was no more than a quarry to provide material to strengthen the ramparts. This was recently refuted when Cunnington's pottery assemblage was re-interpreted and found to contain Grooved Ware. This pottery type is typical of Late Neolithic Henge Enclosures such as Durrington and Marden, and

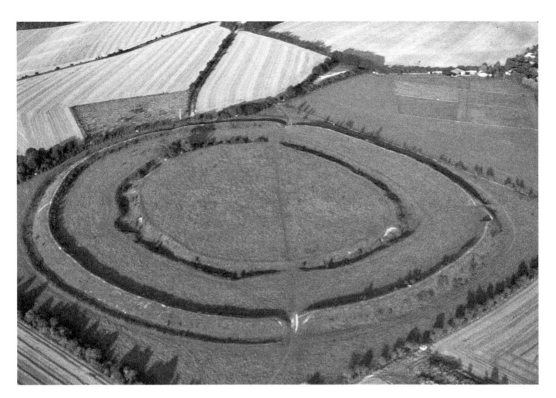

Figsbury Rings, viewed from the south. The two ditch-works are easily recognisable from the air. (Bob Clarke)

lends weight to the ditch actually belonging to a much earlier monument. As to the existence of a bank, a geophysical survey undertaken by the Ancient Monuments Laboratory in 1981 proved inconclusive. That said, the inner ditch is probably a much earlier Class II Henge – that is, two opposing entrances– the original external bank was probably removed for rampart strengthening around 1,500 years later.

Yarnbury Castle

Yarnbury Castle is located at NGR SU 035 403. The enclosure is situated on the northern side of the A303, making visiting extremely problematic, further exacerbated by the fact the road is a dual carriageway at this point. That means an approach from the west only, travel past the site 300 m and then take a left turn onto the bridleway. That said, a number of footpaths and bridleways converge on the site, so it is possible to visit with a 3–4 km walk from most directions.

Yarnbury Castle is the largest prehistoric monument in the Stonehenge region. This multi-vallate site encloses 10.5 ha with an impressive series of bank and ditch circuits.

Work on Iron Age sites, especially hillforts, in the south-west has been driven by substantial investigations at Danebury, near Andover. Excavations spanning twenty years and a large series of field surveys now allow us to recognise specific traits in other locations – Yarnbury Castle

99

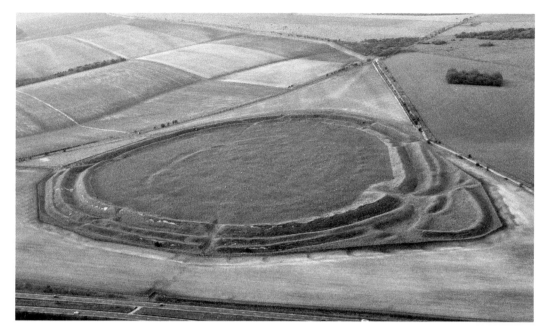

Yarnbury Castle from the south. The impressive entrance can be clearly seen to the left of the picture. (Bob Clarke & Martin Kellett)

falls into that category. The earliest period of occupation demonstrated through excavation is a smaller, 3.7 ha enclosure central to the later site. An excavation conducted by the Cunningtons in 1932 was intended to ascertain the nature and date of the central feature. Though little survives of the bank, a ditch, 2.7-m-deep and still visible, was recorded during the work, displaying the typical 'V' sectional profile indicative of Iron Age ditches. An entrance on the west of the circuit was controlled by a gate. During the third and second centuries BC, Yarnbury became a much more important site. New circuits were added, comprising two huge bank and ditch arrangements, with a third, slighter one outside. Interestingly, there is the chance to recognise a little of how this later site was constructed. The ramparts at Yarnbury appear to have been constructed by digging straight lengths rather than following the contours of the underlying geology. This is best recognised in the abrupt changes of alignment the vallum makes along its route. Also, there are a number of quarry scoops immediately inside the bank, demonstrating that the final defences of the site were probably scree-based. A typically strong, elaborate entrance-way was placed at the eastern point of the ditch. The entrance earthworks clearly have a control function, whilst the shape and sheer size is intended to impress. As visitors enter the enclosure, they are flanked on either side by in-turned banks, controlling access to the inside of the hillfort. An earlier entrance almost directly opposite this has been blocked. Both this and elaboration of entrances are clear markers of developed Hillforts.

A number of large, linear boundary ditches run to the site, but interestingly there seem to be no fields close to the hillforts. Other similarly dated sites in the area appear to have the same landscape arrangement. Yarnbury Castle does have other, similarly dated sites close by. When the A303 to the south-east of the hillfort was widened an enclosure covering 3

ha was discovered. Limited recording demonstrated that the pottery types closely matched those found on Yarnbury and may have played some supporting function to the occupation of this landscape. Much later, Yarnbury Castle was the site of an annual sheep fair. This ran from the early eighteenth century through to 1916, by which time a large number of pens had been built inside the enclosure; traces are still visible in the eastern sector of the site.

Winklebury Hill

Winklebury Hill is located at NGR ST 952 218. Access to this site is difficult – public access is via a footpath that passes along the western side of the site. Park in the centre of Berwick St John, then head out on the road past the Prior for 600 m, and take the footpath south. Around 300 m down the path you will encounter Winklebury spur. If you follow this track, you will pass the hillfort. Around 1 km on take the footpath north-west, down onto the road, then follow it north back to the village. This route is around 4 km and has some steep climbs.

Winklebury Hill is located on a promontory, projecting north into the River Ebble valley. This, in turn, forms part of the northern scarp of the chalk massif of Cranbourne Chase. The site is clearly intended to influence or control traffic through the valley, as it creates one half of a topographical restriction at the western end of the river.

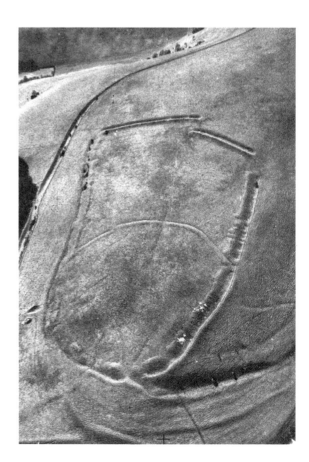

Winklebury Hill from the north, showing clearly the three phases of construction on this site. (Wiltshire Heritage Museum)

Very little true excavation work has been undertaken on the site, save that conducted in 1881/82 by General Augustus Henry Lane Fox Pitt-Rivers, acknowledged father of modern archaeological techniques and owner of Cranbourne Chase. Eight pits were investigated, containing artefacts that confirmed an Iron Age date. The artefacts included loom weights and a spindle whorl, both connected with the production of clothing, also pottery, and wattle and daub. A possible hut circle was partially investigated – the interpretation being strengthened by the wattle and daub. Finds in the immediate area, predominantly pottery, suggest the area was intensively utilised throughout the Iron Age period.

Excavation aside, what makes Winklebury so interesting is the easily recognisable multi-phase layout. This can be clearly seen from the air. Two cross-dykes were dug across the neck of the spur and access was via an offset causeway. Later, the earthworks were strengthened when a univallate bank and ditch was partially constructed around the spur. It would appear this was not completed, as some of the ditch line has been marked out but not dug to the full depth. In a later episode of construction, a crescent bank and ditch arrangement was constructed across the end of the site. The first two events mirror techniques on other West Country sites, but further work is needed to ascertain the relationship of the third work with the previous two.

Old Sarum

Old Sarum is located to the north of Salisbury on the A345 from Amesbury at NGR SU 1380 3270. There is a car park on site. Access to the walls, earthworks and cathedral are free; however, there is a charge for entrance into the castle site.

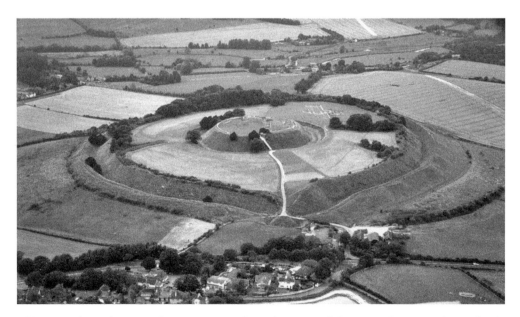

Old Sarum from the east. The Iron Age site's exploitation of the natural topography is clearly recognisable. The mound in the centre originates in the Early Medieval period. (Bob Clarke)

The earthworks at Old Sarum span at least 1,500 years of occupation. Two phases are most recognisable – the Iron Age and early medieval periods. The Hillfort stands at the end of a flat chalk spur overlooking the River Avon, an important trade route from Salisbury Plain to the sea.

The defensive aspects of the hillfort are well-preserved. A multivallate earthwork surrounds a 13 ha site with commanding views to the north, south and west. It is also probable that the outer works of the present entrance owe their appearance to Iron Age civil engineers. The castle and cathedral have been the focus of many archaeological investigations, especially throughout the twentieth century. Thankfully, this has also recovered evidence of the site's prehistoric origins, often slight but nonetheless informative. At least two pits containing Iron Age material were uncovered in the motte area in 1948, and metalwork following the La Táne III style has also been unearthed.

Probably the most convincing evidence for an Iron Age site came during the excavation of a tunnel, first noted in the Gentleman's Magazine for 1795. In 1957, a team placed a trench across the area of the entrance of the tunnel and relocated it. During this work, it was discovered that the entrance to the tunnel probably followed the steady incline of an Iron Age entrance. Sealed within the primary layer were a number of courseware sherds indicative of the late prehistoric period, this included one haematite-coated sherd. As with many Iron Age sites, by the Roman period the focus appears to have shifted outside the earthworks. A substantial settlement with at least four major Roman roads converging on it lies just south-west of the site. By the early medieval period, a settlement had re-appeared within the vallum, and by 1004 a mint was in operation there. This appears to have been formalised under the Crown from 1086 when the development of Old Sarum into a great medieval centre had begun in earnest.

7

Further Sites

Giant's Cave Long Cairn

Giant's Cave Long Cairn is located at NGR ST 823 830, to the south-west of the village of Luckington. Due to the tree cover, this site is best visited in winter. It is possible to park off Allengrove Road opposite the cairn.

Giant's Cave Long Cairn is located on the border between Wiltshire and Gloucestershire, near the village of Luckington. The cairn makes use of a small rise above the flood plain of the River Avon, at this point just a small stream, to accentuate its size. The site has bee much-damaged by previous investigations.

Giant's Cave from the road. The site is much-damaged, but still recognisable. (Bob Clarke)

The excavation at the western end of the barrow has revealed something of the construction of this site. (Bob Clarke)

Three of the four chambers are marked by protruding limestone orthostats. The fourth is marked by a depression. (Bob Clarke)

Giant's Cave falls into the regional class of long barrows known as the Cotswold–Severn type. It has a classic trapezoidal shape aligned almost perfectly east to west. The surviving monument is 43 m in length and varies in height between 2 m and 0.8 m. The central area of the cairn has been badly disturbed by stone robbing from at least the seventeenth century, the condition further exacerbated by two excavations in the twentieth century. In AD 1932, Passmore demonstrated the existence of three lateral chambers. This was increased to four by the efforts of J. Corcoran between 1960 and 1962. The three chambers excavated by Passmore can be easily recognised, as the orthostats from each protrude from the cairn, the fourth appears as a depression in the mound. Human remains and worked flint were discovered in all four chambers. The more recent work also demonstrated the cairn had a 'horned' forecourt containing a blind entrance at the eastern end. The cairn is constructed of limestone dumped within a revetment. The cutting placed across the western end of the monument is still visible, allowing the core of the cairn to be seen.

Snail Down Barrow Cemetery

Snail Down Barrow Cemetery is located at NGR SU 219 521. Access to the site is restricted; however a public footpath does run by the cemetery but please take notice of the signage and any flags.

Snail Down Barrow Cemetery is one of the finest Wessex groups in the South-west.

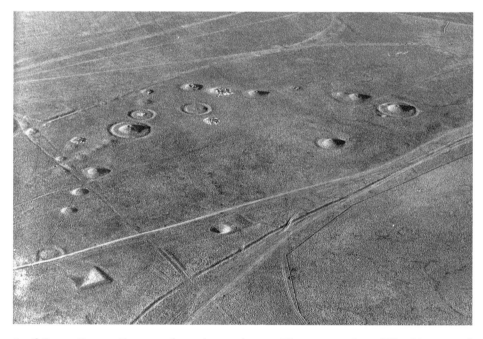

Snail Down Barrow Cemetery from the south-west. There are an incredible thirty round barrows in this photograph. The group is dominated by bell barrows. (Wiltshire Heritage Museum)

Thirty-three barrows, of all known types, are laid out in an arc extending over 800 m. It is worth pointing out from the outset that access to this site is difficult. A public footpath does run through the cemetery, but the area is a designated 'Drop Zone' for the military so please do not access the site during the week or if you see red flags flying.

The cemetery has seen a number of excavations. The ones conducted between 1953 and 1957, under the direction of Nicholas Thomas and Charles Thomas, were the most extensive. This was partially in response to the damage caused by tanks during the Second World War. The burial rite across the site was predominantly cremation and finds, though modest during this campaign, have been complemented by artefacts recovered in earlier nineteenth-century excavations. Many are housed at the Wiltshire Heritage Museum. A Beaker period settlement is also suspected through the discovery of slight occupation, including the distinctive pottery, close to the cemetery.

Suspected Stone Circles

The problem with North Wiltshire, especially around the Avebury complex, is the amount of possible stone circles recognised over the last 300 years. For decades, accounts by the likes of William Stukeley and John Aubrey of monuments either no longer extant or seriously modified have been pilloried as no more than antiquarian fantasy. The story of the Beckhampton Avenue is a good case-in-point. Stukeley in the early eighteenth century illustrated two Avenues at Avebury, but it became traditional to refute the existence of a double stone row running west from the Avebury monument to two standing stones known locally as Adam and Eve. In 1950, Stuart Piggott, in his biography of Stukeley, suggested it should fall to the modern archaeologist to 'disprove' its existence. The evidence from those modern archaeologists can be found on page 47 of this guide. Clearly there are still discoveries to be made in the study of lithic monuments. The following sites demonstrate some current quandaries.

Winterbourne Bassett

The currently scheduled site is located next to the Winterbourne Bassett–Clyffe Pypard road at NGR SU 0936 7552. The site now proposed by Jim Gunter is at SU 0921 7532. Don't be fooled by the standing stone on the field edge. Just to underpin the problem, substantial sarsens are still being ploughed out today; this standing stone it is a very late twentieth century erection!

In 1743, William Stukeley published an account of a 'double circle of stones' at Winterbourne Bassett, situated in a field north-west of the village church. It was a further seventy-eight years before the site was again noted, this time by Richard Colt-Hoare. His position has been accepted as the site of the circles until recently. Further antiquarians visited and illustrated the site in the late nineteenth century – by this time substantially denuded by stone robbing. In 1924, the site was scheduled as an Ancient Monument comprising six recumbent stones, four in a possible arc, one near the proposed centre and a further stone near the field entrance. Then, in 1998, the Ancient Monuments Laboratory conducted a geophysical survey of the site noting that the possibility of a stone circle was at best 'tentative'.

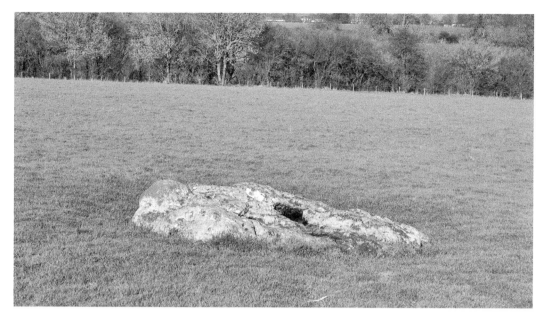

A recumbent stone at the currently scheduled site of the stone circle at Winterbourne Bassett. (Bob Clarke)

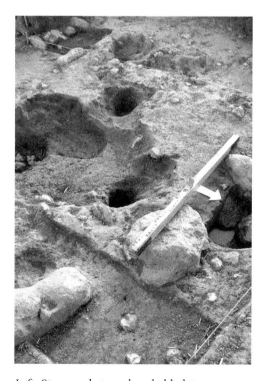

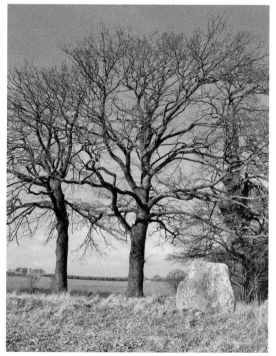

Left: Stone sockets and probably later post-holes in trench 1, at the proposed site of the Winterbourne Bassett stone circle. (Jim Gunter)

Right: The most modern of standing stones! (Bob Clarke)

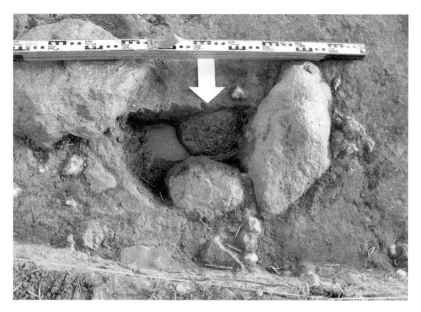

Stone hole and post-packing, including a probably imported igneous stone (*indicated by arrow*), at the proposed site of the Winterbourne Bassett stone circle. (Jim Gunter)

Moreover, when the illustration Stukeley produced 250 years previously was revisited, it was obvious the scheduled monument was not in the same field as that the antiquarian had drawn. In the distance, Stukeley placed the church at Avebury and Silbury Hill, neither of which can be seen from the scheduled area. Further, Stukeley notes the monument was 'upon elevated ground'; the current proposed site is located on a north-facing slope with no possibility of viewing either Avebury feature. It would be easy to suggest Stukeley exercised a level of artistic licence in his illustration; however the poor results from the geophysics point to Colt-Hoare having got the location wrong. Recently, Jim Gunter has led a successful excavation of the field to the south of the current scheduled site. It is clear from this work that the site described by William Stukeley has now been re-located.

Day House Lane

The Day House Lane site is scheduled, so no matter what the outcome of planning, the monument will remain. There is no direct public access to the site, but you can easily view the stones from the verge of this quiet lane. The site now straddles Day House Lane at NGR SU 1814 8235.

The Wiltshire County Council Sites & Monuments Record says it all: 'A dubious stone circle recorded by A. D. Passmore.' Arthur Passmore was well-known to the county archaeological community. He had placed notes and papers on a multitude of subjects in the Wiltshire Archaeological and Natural History Magazine for over fifty years. Recently, Aubrey Burl, nationally recognised authority on stone circles, published Passmore's notebooks, in which he discussed at length the Day House Lane site plus stone rows and a further, smaller circle close by. Passmore presented a paper to the society in 1894 on the site and published it the same year.

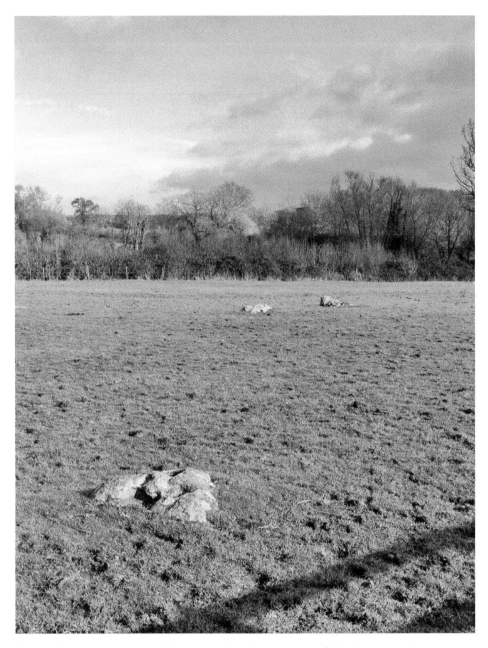

Three of the stones suspected by many to be the remnants of the Day House Lane stone circle. (Bob Clarke)

He, however, was not the first to recognise the significance of the site; the circle was first noticed some fifty years earlier by notable Swindonian Richard Jefferies in 1848. Five stones are currently visible, all recumbent, forming an estimated diameter of *c.* 92 m. In recent years, the site of the Day House Lane Circle has taken on a new lease of life, becoming the central argument in the battle against the continued development of the south-east of Swindon.

Falkner's Circle

The remaining standing stone can be found at NGR SU 1095 6942, a few hundred metres to the east of the road, running parallel with the West Kennet Avenue.

This small, much-destroyed, stone monument was first described by Richard Falkner in 1840. Work undertaken in 2002, including a geophysical survey and excavation, has confirmed the presence of the features recorded by Falkner. The investigation demonstrated a circular setting *c.* 44 m in diameter, made up of ten to twelve stones. Only one setting would appear to be out of alignment and all are possibly intentionally spaced at around 10–12 m. No buried stones exist; the evidence for them survives as stone sockets or destruction pits. The finds included an abundance of worked flint and two sherds of Grooved Ware, a pottery type intimately linked with henge monuments. Today, just one stone is visible near the hedge line. The investigation showed that this stone has around 0.5 m of sub- and topsoil build-up, meaning the stone, when first erected, would have reached 1.8 m high. At Falkner's Circle, the appearance of the standing sarsen has been used to show that it was probably brought to the site. Naturally occurring sarsens in the immediate area have a quite distinct reddish hue to them, whereas this singular example conforms more to the standard grey utilised in many of the local monuments.

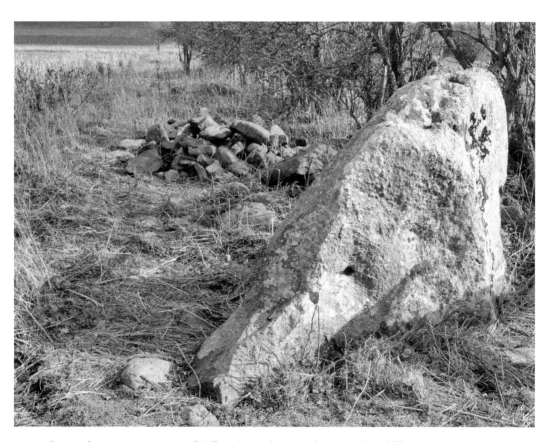

The single remaining stone of Falkner's Circle. Note the very clear difference between the colour of the standing stone and the pile of recent field clearance sarsens. (Sarah Clarke)

8

How do we know what we know?

Barrow Excavation

Tumuli – burial mounds or round barrows – are the most copious of the prehistoric sites in the county and, indeed, the whole of the United Kingdom. Unfortunately, this makes them vulnerable, especially to damage by ploughing, and not just recently, as you might

Group of Barrows, South of Stone Henge.

'Group of Barrows, South of Stone Henge'. This is a watercolour by Philip Crocker, Sir Richard Colt-Hoare's surveyor and draftsman. The work dates *c.* 1806, and is probably of excavations on Normanton Down. This is how many barrows in the area were opened during the nineteenth century. (Wiltshire Heritage Museum)

expect. Barrows have been systematically removed since the Iron Age. And if that is not bad enough, over the last 300 years, these sites, stories of gold, have attracted the attention of farmers, landowners and antiquarians. All this means the opportunity to investigate a barrow that has not been previously opened is probably impossible now. This attrition has slowed over recent years, but that said, the last 100 years has presented its own problems. This means you are unlikely to see a complete barrow cemetery on your visits to prehistoric site in the county. What follows are the fortunes of a few barrows north of Boscombe Down in an area known as Earl's Farm Down as mapped through excavation practices.

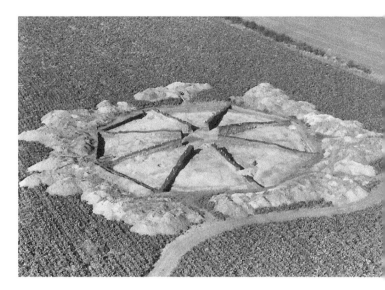

In 1961, Patricia Christie, on behalf of the Ministry of Public Buildings and Works, excavated two 'fine round barrows'. The reason? 'Although scheduled, the farmer had asked for the removal of these barrows as the caused obstructions to mechanized cultivation'. The two monuments were radically different. This one was predominantly a turf stack, with a singular cremation, pottery and worked flint along with a singular posthole. (Boscombe Down Conservation Group)

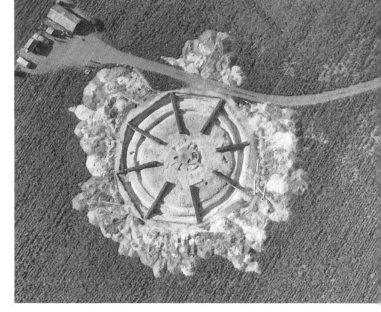

The second of Christie's digs. This site was one barrow imposed over the top of an earlier, smaller structure. This can be plainly seen from the two ditches. The original burial was a Beaker. The spokes in this and the previous photograph are balks left in by the excavator. (Boscombe Down Conservation Group)

In early 2002, the north-west of the Down was sold for development. Naturally, there was an archaeological excavation, this time led by AC Archaeology. This aerial photograph demonstrates what can be encountered. All of this had been ploughed flat at least fifty years previously. The rings are barrow ditches; two lines are late-Bronze Age boundary ditches, whilst the mottled marks are tree throws. (Bob Clarke)

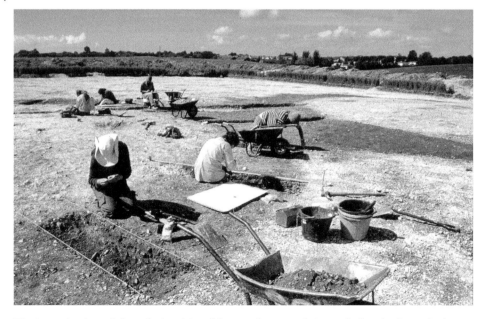

The investigation of the relationship of the two barrows (*pictured above*) whose ditches meet. (Bob Clarke)

This aerial photo of a small cemetery, a few hundred metres east of the now removed barrows, was taken in 1999. It depicts a scene that could be witnessed up and down the county until very recently. The mounds of the barrows are Scheduled Ancient Monuments, ensuring they are protected, but note the Bronze and Iron Age field systems that are being destroyed by the plough. The barrow cemetery is steadily being placed out of context by this continued damage. (Boscombe Down Conservation Group)

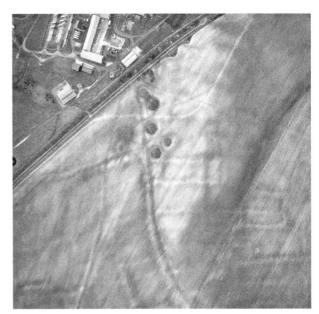

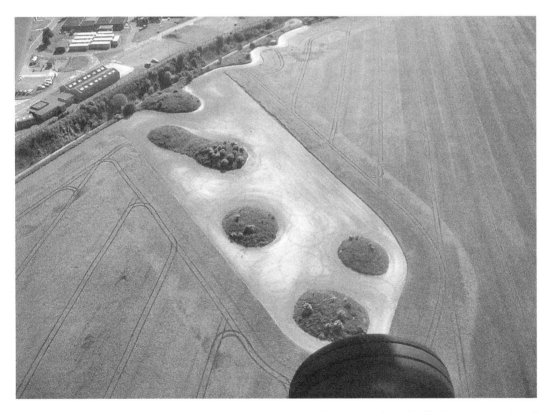

By 2004, the cemetery had been moved out of danger, with a 'buffer' zone introduced between arable land and the monuments. But what about the field systems? (Boscombe Down Conservation Group)

Experimental archaeology – a way to understand the past

By Katy Whitaker

Experimental archaeology can be defined as a scientific research method, a sub-discipline of archaeological science that is characterised by high levels of actualism. Actualism allows the archaeologist to move from the highly controlled conditions of the laboratory experiment into 'the real world', testing theories about the past using authentic materials in conditions that are closer to real life. For example, the geochemical and petrological qualities of a rock-type can be analysed in the laboratory, but the technological qualities that contributed to that stone's selection for making ground and polished axe heads must be sought through manufacture and use experiments with replica tools performing real tasks such as carpentry and woodland clearance.

Crucially, experimental archaeology tests hypotheses through replicable experiments. This clearly distinguishes it from 'reconstruction' or 're-enactment' activities. There are generally acknowledged to be five broad types of experiment, and Wiltshire has a distinguished reputation in the most complex of these – eventuality trials.

Eventuality trials are large-scale, long-duration experiments. Examples include tests of theories about prehistoric grain storage, or the effects of ploughing on buried archaeological deposits. Eventuality trials concerned with understanding archaeological formation processes began very early on in Wessex, when, in 1893, Pitt-Rivers left his excavated ditches of the Wor Barrow on Handley Down open for four years to observe how they silted up again. Long-term experiments like this are necessary to challenge assumptions that are made about the archaeological record.

None are longer-term than the Experimental Earthworks Project. Intended to test theories about archaeological deposits in prehistoric bank and ditch systems, in 1960 an earthwork was built on the chalk of Overton Down, near Avebury, followed by another in 1963 on the sands near Wareham, Dorset. These monuments, carefully designed and recorded as built and seeded with artefacts, are excavated at intervals over a 130-year period, to show how they change through time. This exposes the assumptions that archaeologists make about the stratigraphy that they excavate. The outstanding ambition of an archaeological experiment scheduled to last more than five generations is unparalleled, and the project's interim results have already influenced archaeological interpretations.

Inspired by this project, other smaller, experimental earthworks have been built around the world, including another in Wiltshire – one of Peter Reynolds' octagonal earthworks in Wroughton. More recently, English Heritage's Matt Canti has set up an experiment (also in Overton) to test a theory about the way that the earliest deposits at Silbury Hill were formed. Whether we are analysing the residues of technological processes, or studying what happens when a round-house decays, experimental archaeology is an extremely valuable methodology that helps us to understand why the archaeological record is the way that we find it.

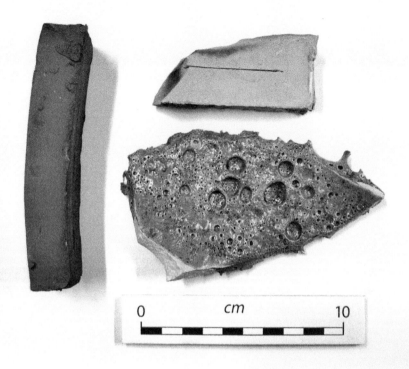

Several secondary clays, gathered by hand from near-surface sources, were tested to ascertain their potting qualities. The aim was to determine the clays' qualities of plasticity, strength, thixotropy and drying, which need to be understood if the clays are to be used in actualistic experiments. The photograph shows test tiles using a single clay from Charmouth in its air-dry state, fired to 900 C and 1,280 C respectively, at which temperature it became completely vitrified. The tests showed that this clay develops good thixotropy and has a high water-of-plasticity percentage, but that its high shrinkage rate makes it more likely to crack and warp without the addition of non-plastic tempers. It is a highly fusible clay with a narrow firing range and high carbon content, so particular care needs to be applied to its firing. (Katy Whitaker)

Conservation

Whilst the prehistoric monuments of Wiltshire may appear permanent, surviving the ravages of time, they are in fact extremely fragile. Agricultural practices spanning centuries have steadily removed many of the earthwork features the county once contained (*check the Barrows section*). Further, many of the lithic monuments we have described have suffered greatly from stone robbing and clearance. The conservation of our prehistoric heritage comes at a price: often a careful balance between visitor access and footfall erosion has to be struck. There is nowhere better to witness this than at Avebury. Occasionally, the management of visitor traffic is not enough and intrusive work is required to ensure the monument's survival. In recent years, some of Wiltshire's more famous sites have seen major work. One area, which has seen careful management of the archaeology over the last twenty years, is Salisbury Plain. A huge conservation effort, managed by Richard Osgood, has ensured all prehistoric monuments exist alongside manoeuvres.

Erosion tracks

People are creatures of habit. In all the years I taught archaeology, the one thing that never ceased to amaze me was the ability of students to stick to the path – even when there was no need. This aerial shot of Avebury, in the summer of 2003, adequately demonstrates the erosion caused by thousands of feet walking along the top of the bank.

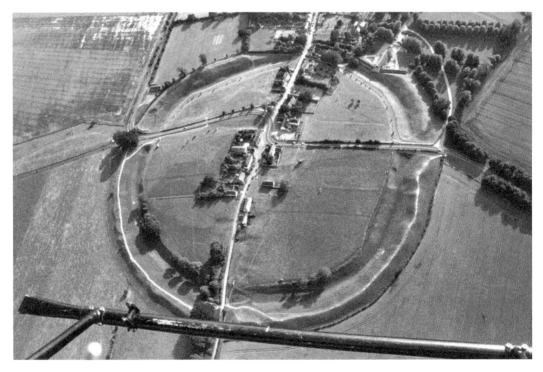

Erosion at Avebury. Many pairs of feet soon wear away the grass, and then the underlying monument, if not carefully managed. (Bob Clarke)

The 'contraption' used to support the Cove stones whilst the bases were excavated and re-cemented in. (Bob Clarke)

Gravity

In 2003, the two stones that form the Cove, inside the Avebury henge enclosure, were the subject of major engineering works. For the previous three years, access had been restricted due to the apparent lean they were developing. The areas around each were excavated, and then the base of the stone was secured – or that was the plan. On excavation, it was found that the bigger of the two was like an iceberg: two-thirds were still underground, and unlikely to move due to this. On the reverse, it did provide an insight into how Avebury was erected, clearly this stone had not been moved very far, suggesting some of the larger sarsens may have been in situ when the ditch was dug.

Previous Investigation

Successive investigations at Silbury, especially those since the mid-eighteenth century, had left the monument in danger of collapse. Renewed fears for its future were prompted by the collapse of the shaft from the summit. In 2000, English Heritage embarked on an ambitious project to consolidate the monument, and in the process recorded a vastly more complex structure than had been previously thought. Surprisingly, the last work done internally in the late 1960s had not been backfilled correctly, causing the whole mound to become unstable. Through an ambitious collaboration, a number of civil engineering processes were employed on the site. All voids within the monument have now been filled and Silbury Hill is assured a stable future.

The entrance to Silbury Hill during rescue and restructuring work. (Bob Clarke)

Once animals get into the archaeological layers, much information is lost. This site on Salisbury Plain demonstrates what damage can be done in a very short space of time. In this pile is animal bone, prehistoric pottery and antler. (Bob Clarke)

Animal Intrusion

There are two things above all others likely to disturb the context of an archaeological site – rabbits and badgers. On a hard geology like the chalk, the fill of a ditch or the rubble make-up of a burial mound makes an attractive proposition to these animals. After years of warfare, it appears both rabbits and badgers have now met their match. Trials of specific types of fencing, by Richard Osgood of the MoD, on Salisbury Plain, have now begun to pay off, and, when combined with restricted access, should ensure a better future for the county's archaeological sites.

New wiring techniques surrounding vulnerable sites are beginning to take effect. Note the small one-way gate to allow badgers out but not back in, and the signage warning the military from driving tanks and trucks over the monument. (Bob Clarke)

Further Reading

I decided early on that we should not overburden the text with references. That said, here are the titles that I think best expand upon some of the sites mentioned here. This is by no means a comprehensive list, and I am sure my colleagues would have chosen differently; however, many of these worked for my students for many years.

Bewley, Bob, *Prehistoric Settlements* (London: Batsford, 1994)

Burl, Aubrey, *A Brief History of Stonehenge* (London: Robinson, 2007)

Cunliffe, Barry, *Iron Age Communities in Britain* (Routledge, 2009)

Grigson, C. Whittle, Alasdair & Pollard, Josh, *Harmony of Symbols: The Windmill Hill causewayed enclosure* (Oxford: Oxbow, 1999)

Hillson, S. Bell, Martin & Fowler, Peter, *The Experimental earthworks Project 1960-1992* (Council for British Archaeology Research Report 100, York: Council for British Archaeology. 1996)

Lawson, Andrew, *Chalkland: An Archaeology of Stonehenge and its Region* (Salisbury: Hobnob, 2007)

Leary, Jim & Field, David, *The Story of Silbury Hill* (English Heritage, 2010)

Parker Pearson, Michael, *Bronze Age Britain* (London: Batsford, 1993)

Pitts, Mike, *Hengeworld* (Arrow, 2001)

Pollard, Josh & Reynolds, Andrew, *Avebury: The Biography of a Landscape* (Stroud: Tempus, 2002)

Pryor, Francis, *Britain BC: Life in Britain and Ireland Before the Romans* (Harper Perennial, 2004)

Pryor, Francis, *Farmers in Prehistoric Britain* (Stroud: Tempus, 1999)

Reynolds, Peter, *The Nature of Experiment in Archaeology*, in Harding, A.F. (ed.) *Experiment and Design: Archaeological Studies in Honour of John Coles* (Oxford: Oxbow Books, 1999)

Roberts, Neil, *The Holocene: An Environmental History* (Oxford: Blackwell, 1998)

Journals:

As I said at the beginning of this guide, a majority of the information has been drawn from the pages of the *Wiltshire Archaeological and Natural History Magazine*. The publication has recently celebrated its 100th edition and has reported much of the work carried out on the prehistoric (and historic) monuments of the County of Wiltshire.

The Prehistoric Society concerns itself with the period extending from the earliest human origins to the emergence of written records. The *Proceedings of the Prehistoric Society* has over the years contained many sites from Wiltshire.

One further journal, *Antiquity,* should also be explored, as it often themes current research.

The Field Team

Hannah, Sarah and Alice Clarke.
(Bob Clarke)

Above left: Mark Hayter. (Bob Clarke)

Above right: Richard Johnson. (Bob Clarke)

Mike Fuller (left). (Hannah Clarke)

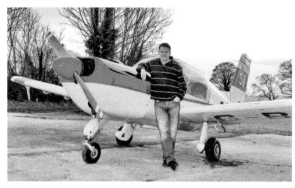

Martin Kellett. (Bob Clarke)

Katy Whitaker

Bob Clarke. (Hannah Clarke)

Prehistoric Gloucestershire
TIMOTHY DARVILL

Gloucestershire is one of Britain's richest counties in terms of its archaeological heritage. Scattered across the high blue hills of the Cotswolds, along the valleys of the Severn, Avon, and Wye, and through the Forest of Dean is wealth of sites and monuments that allow us to understand the many prehistoric communities who once lived, worked, and died there. From the camps and caves occupied by hunter-gatherer groups visiting the area during the last Ice Age, through the long barrows and camps of the first farmers, to the massive hillforts and enclosures built by Celtic chieftains in the centuries before the Roman Conquest, this book charts the story of the landscape and its inhabitants over a period spanning more than half a million years.

ISBN: 978-1-84868-420-1 £18.99

Hadrian's Wall: A History & Guide
GUY DE LA BÉDOYÈRE

Stretching 73 miles from coast to coast and reaching a height of about 13 feet, Hadrian's Wall should have been counted as one of the seven wonders of the ancient world. Today, a World Heritage site, it stands as the most imposing monument north of the Alps and attracts millions of visitors a year.

Yet, despite all the excavation and research that has been carried out, this is the first detailed guide to be written for many years. Having first dealt with the practical questions of transport, clothing and maps, Guy de la Bédoyère explains why and how the Wall was constructed.

This indispensable guide-book concludes with a list of dates, a glossary and a summary of all the key sources.

ISBN: 978-1-84868-940-4 £18.99

John Aubrey and Stone Circles: Britain's First Archaeologist
AUBREY BURL

John Aubrey is best known for his gossipy *Brief Lives*, but Aubrey Burl, the world expert onstone circles, argues he should be equally celebrated for his discovery of the age and wonders of prehistory, Britain's stone circles.

In 1649, out hunting he chanced upon the wonders of Avebury. They fascinated him. The stones were clearly some form of temple, and as they were found in places where neither Roman, Saxon nor Dane had been they must have been erected before them when the only priesthood were the Druids. Aubrey was the first to have that heretical insight.

Over the years John Aubrey compiled the first, objective compilation of pre-Roman monuments in Britain from the Merry Maidens in Cornwall to the moon aligned recumbent circles of Northern Scotland. Between lay famous rings like the Rollright Stones in Oxfordshire and Long Meg and her Daughters in the Lake District. For years her was 'never off horseback', searching. His scribbled notes formed the foundation of stone circle studies.

ISBN: 978-1-4456-0157-1 £25.00